CHURCHES OF HERTFORDSHIRE

For Isabella

DAVID GOULDSTONE

Love from
Uncle
Dave

18/7/25

AMBERLEY

This edition first published 2025

Amberley Publishing
The Hill, Stroud
Gloucestershire GL5 4EP

www.amberley-books.com

Copyright © David Gouldstone, 2025

The right of David Gouldstone to be identified as the Author
of this work has been asserted in accordance with the
Copyrights, Designs and Patents Act 1988.

British Library Cataloguing in Publication Data.
A catalogue record for this book is available from the British Library.

ISBN 978 1 3981 1929 1 (print)
ISBN 978 1 3981 1930 7 (ebook)

Typesetting by SJmagic DESIGN SERVICES, India.
Printed in Great Britain.

CONTENTS

Map 4

Key 6

Introduction 7

1. Abbots Langley, St Lawrence 8
2. Anstey, St George 11
3. Ardeley, St Lawrence 13
4. Ashwell, St Mary 15
5. Ayot St Lawrence, St Lawrence 17
6. Ayot St Peter, St Peter 19
7. Baldock, St Mary the Virgin 22
8. Bedmond, Ascension 25
9. Bengeo, St Leonard 26
10. Benington, St Peter 27
11. Berkhamsted, St Peter 29
12. Bishop's Stortford, St Michael 32
13. Brent Pelham, St Mary 33
14. Buntingford, St Peter 35
15. Caldecote, St Mary Magdalene (Friends of Friendless Churches) 37
16. Clothall, St Mary 38
17. Flamstead, St Leonard 39
18. Great Hormead, St Nicholas 42
19. Hatfield, St Etheldreda 43
20. Hemel Hempstead, St Mary 47
21. High Wych, St James 49

22. Knebworth, St Martin 51
23. Knebworth, St Mary and St Thomas 53
24. Little Gaddesden, St Peter and St Paul 55
25. Little Hormead, St Mary (Churches Conservation Trust) 57
26. Meesden, St Mary 58
27. Offley, St Mary Magdalene 60
28. Oxhey Chapel (Churches Conservation Trust) 62
29. Preston, St Martin 64
30. St Albans Cathedral 65
31. St Albans, St Michael 68
32. St Paul's Walden, All Saints 70
33. Sandridge, St Leonard 72
34. Sawbridgeworth, Great St Mary 73
35. South Mimms, St Giles 76
36. Standon, St Mary 78
37. Stanstead Abbotts, St James (Churches Conservation Trust) 81
38. Throcking, Holy Trinity 83
39. Walkern, St Mary 85
40. Waterford, St Michael and All Angels 86
41. Weston, Holy Trinity 88
42. Wheathampstead, St Helen 91
43. Wyddial, St Giles 93

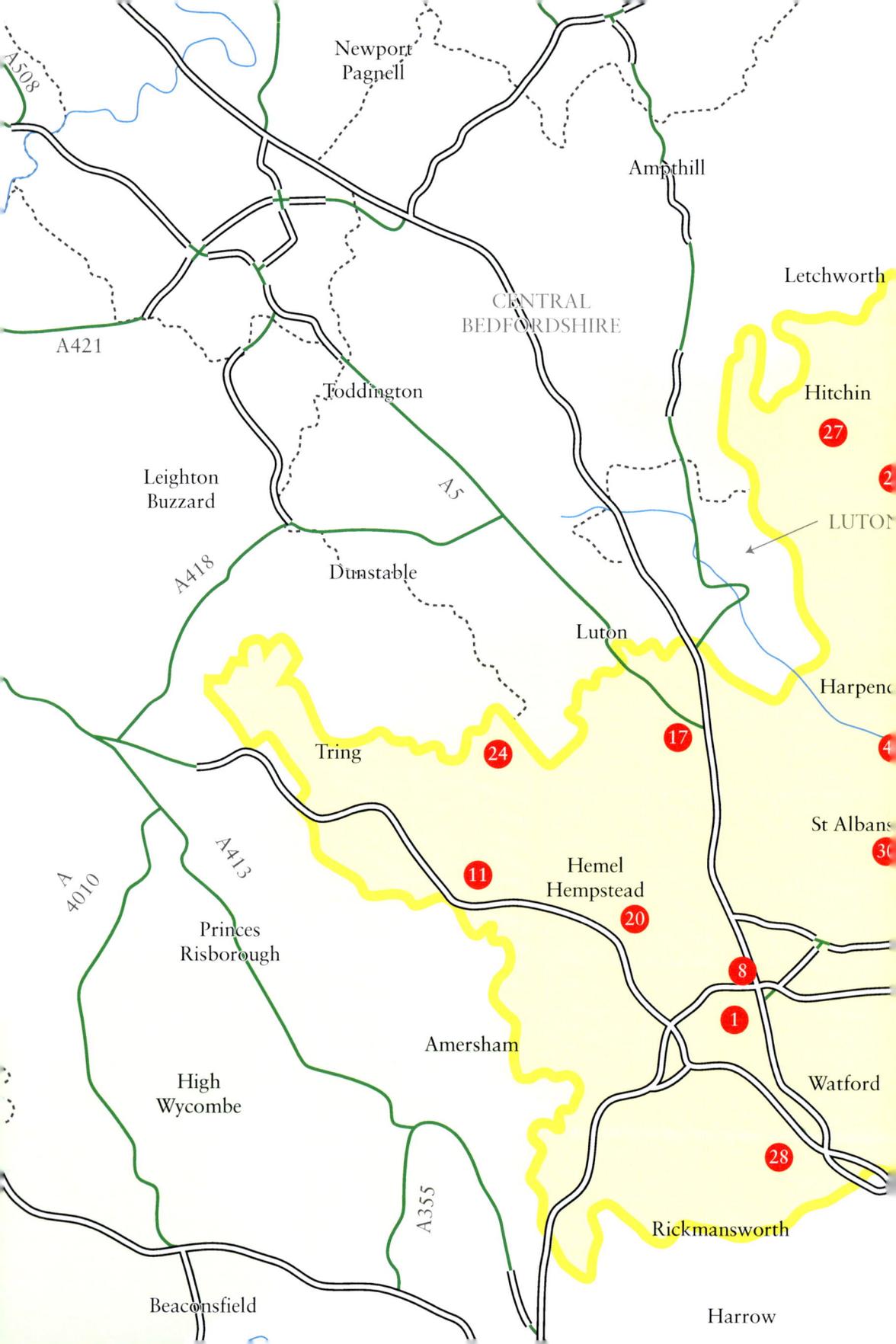

A508

Newport
Pagnell

Ampthill

Letchworth

CENTRAL
BEDFORDSHIRE

Hitchin

(27)

A421

(2)

Toddington

LUTON

A5

Leighton
Buzzard

Dunstable

A418

Luton

Harpend

(17)

Tring

(24)

(4)

St Albans

A413

(11)

Hemel
Hempstead

(30)

A
4010

(20)

Princes
Risborough

(8)

(1)

Amersham

Watford

High
Wycombe

A355

(28)

Rickmansworth

Beaconsfield

Harrow

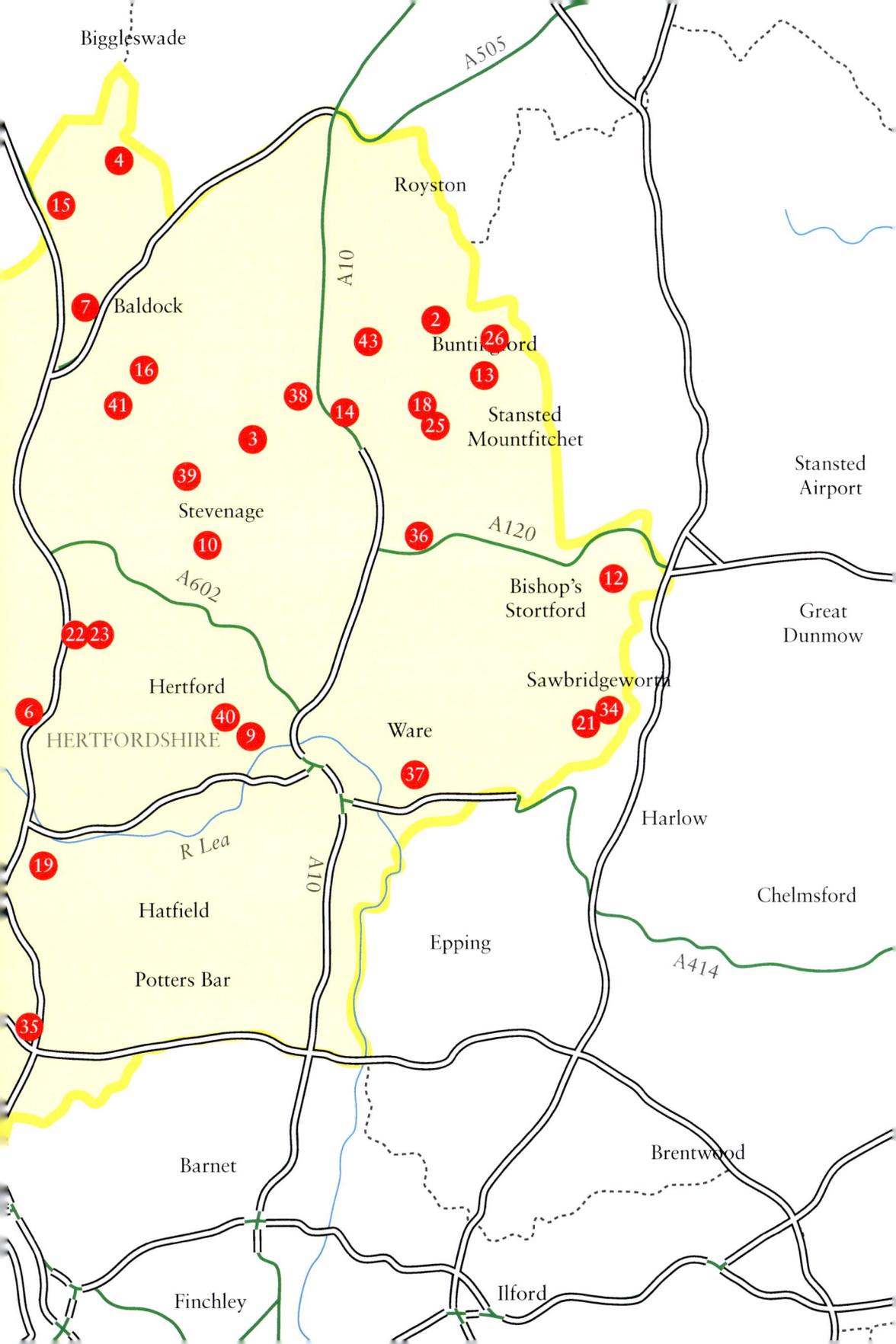

Biggleswade

4

15

A505

Royston

A10

7 Baldock

16

41

2

43

Bunti gford 26

13

38

14

18

25

Stansted
Mountfitchet

3

39

Stansted
Airport

Stevenage

10

36

A120

A602

Bishop's
Stortford

12

Great
Dunmow

22 23

Hertford

Sawbridgeworth

6

HERTFORDSHIRE

40

9

Ware

21 34

37

Harlow

R Lea

19

A10

Chelmsford

Hatfield

Epping

A414

Potters Bar

35

Barnet

Brentwood

Finchley

Ilford

KEY

1	Abbots Langley	23	Knebworth, St Mary and St Thomas
2	Anstey	24	Little Gaddesden
3	Ardeley	25	Little Hormead
4	Ashwell	26	Meesden
5	Ayot St Lawrence	27	Offley
6	Ayot St Peter	28	Oxhey
7	Baldock	29	Preston
8	Bedmond	30	St Albans Cathedral
9	Bengeo	31	St Albans, St Michael
10	Benington	32	St Paul's Walden
11	Berkhamsted	33	Sandridge
12	Bishop's Stortford	34	Sawbridgeworth
13	Brent Pelham	35	South Mimms
14	Buntingford	36	Standon
15	Caldecote	37	Stanstead Abbotts
16	Clothall	38	Throcking
17	Flamstead	39	Walkern
18	Great Hormead	40	Waterford
19	Hatfield	41	Weston
20	Hemel Hempstead	42	Wheathampstead
21	High Wych	43	Wyddial
22	Knebworth, St Martin		

Introduction

My first visit to a Hertfordshire church was in 1957. It was All Saints, Leavesden, an undistinguished work by the distinguished architect George Gilbert Scott. I'm afraid that at the time I paid little attention to the tracery and tympana, or even the corbels and capitals, perhaps forgivably in the circumstances, the occasion being my baptism. It wasn't until the early eighties, when I moved back to the county for my first proper job, that I began a systematic exploration of the county's places of worship, a study (though a non-scholarly one) that has lasted forty years so far and will, I trust, continue a while longer yet.

Scenically, Hertfordshire is genteel and modest. There are no beetling crags or raging torrents. However, despite its proximity to London (it's often easy to forget that nowhere in the county is more than about 40 miles from Trafalgar Square) there are numerous quietly loveable landscapes, and too many attractive towns and villages to mention here. The county's churches are similar in that they're often overlooked and underappreciated, yet they afford many pleasures for anyone who takes the time to look. The pre-Conquest period is only sparsely represented (though there are good examples of Saxon long-and-short work at Reed and Westmill), but nearly all others are covered, including the seventeenth century, which contributed two small but unusually interesting buildings (Buntingford and Oxhey). There's only one from the eighteenth century, but it's the country's first Greek Revival church (Ayot St Lawrence); the Gothic Revival was as active here as it was elsewhere, and even the twentieth century got in on the act with Knebworth St Martin and Stevenage St George.

Hertfordshire's churches are particularly rich in monuments from the sixteenth to the eighteenth centuries, and, while there's not much medieval stained glass, there's plenty of good, and some outstanding, Victorian and modern glass. Carved corbels (designed to support a structural element) and label stops (decorative terminals to the moulding over an arch) abound, and deserve more attention than they often get. Their congregations range from handsome to hideous and back again, their meanings (if any) often puzzling. It's sometimes pointed out that images in medieval churches were a *biblia pauperum*, a bible of the poor, and it's easy to imagine priests using, say, stained glass to explain Bible stories to their parishioners. But it's hard to see how this squares with many grotesque and peculiar carvings, not to mention the probably sexual one in Weston. Some of them must be apotropaic (intended to ward off evil), but this explanation can hardly account for all of them (Great Hormead's hyperactively cheerful moon-faced character or Benington's king with a sword through him, for example).

(In addition to the churches singled out below, I recommend visits to Aston, Abbots Langley, Baldock and, especially, St Ippolyts.)

The only quarried stone available to Hertfordshire's medieval builders was clunch, a type of chalk (which is itself a kind of limestone) that mostly came from Totternhoe in Bedfordshire. This weathers badly, and when used externally decays and crumbles alarmingly, and has in many places had to be replaced in modern times. It would have been expensive too, so it's not surprising that the one variety of stone which was abundant locally, and could be simply picked up in the fields at no cost (except labour), was used very widely: flint. This can be quite attractive when contrasted with brick (as at Oxhey), or in a chequerwork pattern with clunch (Abbots Langley, Baldock and Redbourn, for example), and can sparkle in the sun after rain. But whether it's knapped (split open to reveal the dark interior), which looks gloomy and forbidding en masse, or just as it comes, usually set in an ocean of mortar, which looks speckled and messy, it's rarely very satisfactory. Nevertheless it's ubiquitous, and combined with the propensity for the county's churches to have had their windows renewed in the late Middle Ages (or replaced by the Victorians in that period's Perpendicular style), I've coined the phrase 'Perp'n'flint' to describe them. The use of brick began in the 1520s (South Mimms) and of course went on to have a major impact on the county's landscape, from Oxhey to Knebworth St Martin and beyond.

Spires are rare in Hertfordshire; instead, towers often have slim spirelets, sometimes derisively called candlesnuffers, but more often known as spikes. They provide a cheekily bathetic climax to the skyline – 'dignity crowned by impudence', in Alec Clifton-Taylor's delightful phrase. They're so common that I've rarely thought it worthwhile to mention them, but they're the county's churches' sole original contribution to ecclesiastical architecture. (A few have strayed over the county boundaries, for example, Guilden Morden in Cambridgeshire.)

A book such as this cannot be definitive or comprehensive, even when dealing with a county as small as Hertfordshire; it would be easy to write several books of the same length containing entirely new material. The best this one can hope to do is to whet the appetite. I've had to be highly selective and exclude dozens of fascinating buildings that I'd dearly like to have included and will perhaps be, not without justice, castigated for doing so. I've thought it best to aim for depth rather than breadth, and to allow my prejudices to show without trying to disguise them.

I'd like to thank my wife, Irene, and my son, Luke, who have over the years accompanied me on visits to many of the churches included here. This book is dedicated to the memory of my brother, Steve (1960–2023).

1. Abbots Langley, St Lawrence

This was the probable birthplace of Nicholas Breakspear, better known as Adrian IV, the only English pope (reigned 1154–59). Sadly, there's nothing in the church from his lifetime. The oldest parts are the Norman nave arcades, which date from thirty or forty years later. On the north there are typical scallop and trumpet capitals and responds, but on the south they're stiff-leaf. Are these the result of later recutting, or are they early examples of this motif (a feature of the Early English style of the thirteenth century)?

The next major building phase, in the early fourteenth century, resulted in the south chapel; its display of flint and limestone chequerwork is perhaps the best in the county. The two south windows each have a spherical triangle containing a sexfoil in their tracery, while the east window is a clear development of Early English intersecting tracery. It's a simple design, nothing like as complex as many of the other windows created during the lamentably short-lived Decorated period, but it has poise. Compare it to the bog-standard-boring fifteenth-century Perpendicular windows in most of the rest of the church. Why the seductive sinuous lines of the former were abandoned wholesale in favour of the rigid rectilinearity of the latter beats me. (I make no apology for being cross about something that happened nearly 700 years ago.)

There's a monument to Lord Raymond, Lord Chief Justice and Baron of Abbots Langley (d. 1733). In 1729 he presided over the case of Thomas Woolston, who was tried for blasphemy, having written books maintaining that the Bible must be interpreted allegorically rather than literally. He was found guilty, and Raymond sentenced him to one year's imprisonment and heavy fines. He couldn't pay them and thus had to stay in prison, where he died in January 1733. Less than two months later Raymond followed him; maybe Raymond was able to pompously lecture Woolston about how wrong he was when they met in a literal Heaven. Or maybe not.

Raymond leans on a pile of books and holds the Magna Carta. He seems very self-satisfied, holding out his left hand to a putto, deferentially crouched, who

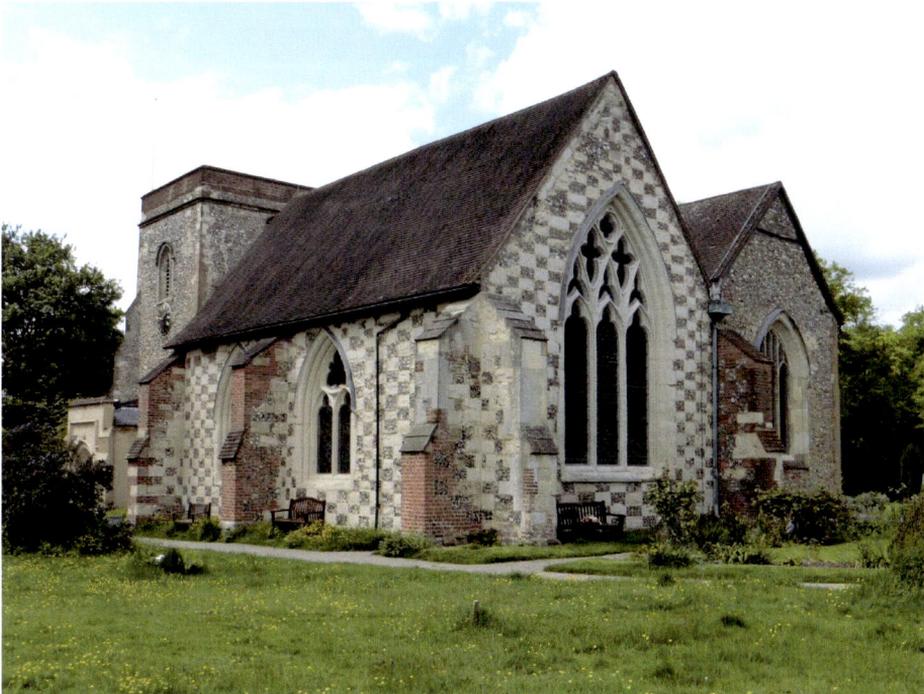

Abbots Langley.

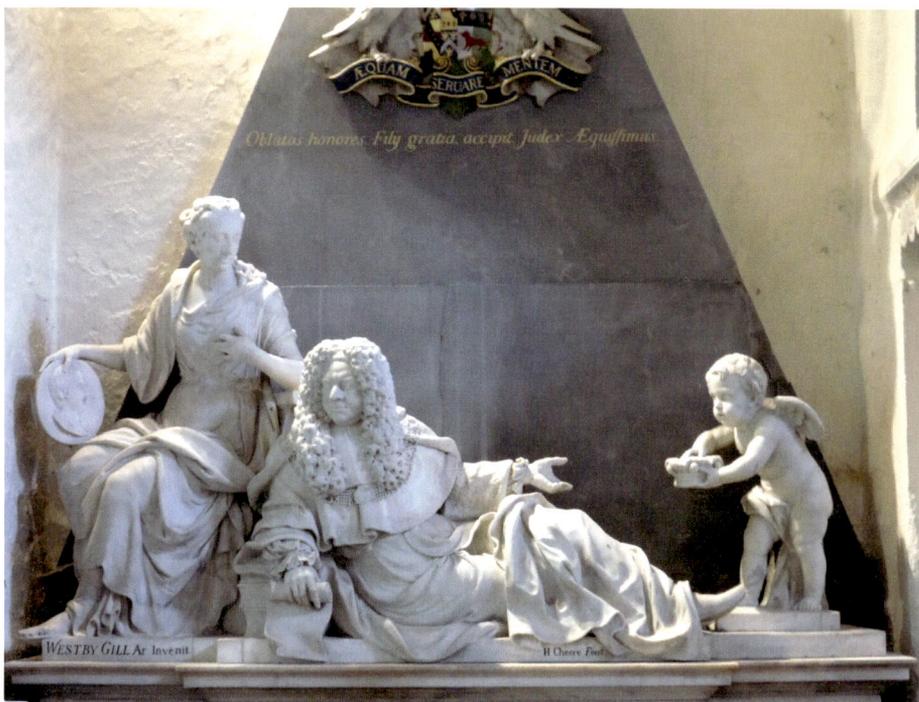

Above: Abbots Langley.

Left: Abbots Langley window by Powell & Sons, 1911.

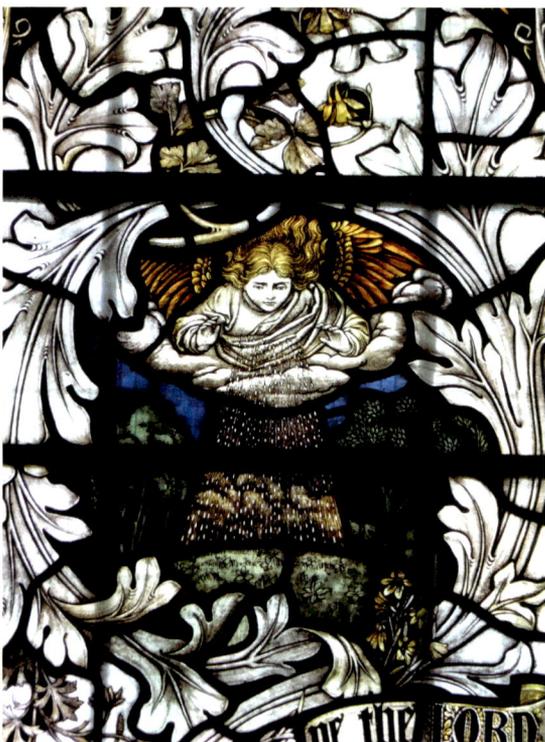

offers him a coronet. He doesn't deign to look at the poor young page, but turns his head away in what looks like a deliberate snub. I suppose anyone with a wig as luxuriant as his is likely to have his self-importance go to his head.

The east window of the south chapel contains stained glass (1911) by James Powell & Sons. There are nine scenes within the lush swirling monochrome foliage, including a starlit, icicle-threatened snowy landscape, a valley thick with corn, a whale unanatomically spouting twin jets of water through its nostrils, and a manically staring Moses with his eyes boring mercilessly into the viewers. It's noble Edwardian Arts and Crafts work.

2. ANSTEY, ST GEORGE

Before entering the church stop and look at the fifteenth-century lychgate, with its mossy tiled roof and stylish little gablets. The eastern third has been enclosed with flint and brick. This is puzzling at first; it's not at all normal for lychgates to have walls. Extraordinarily, this portion has been converted into a lock up. This happened in 1831, possibly as a result of the Swing Riots, when agricultural workers rose up in protest against their working conditions. As far as I know, this is the only lychgate lock up to be found anywhere.

The heart of the church is Norman; the four robust arches of the central crossing are Romanesque and probably date from the late twelfth century, and have roll mouldings and shaft rings, though the curious capitals on the west, now mostly broken, can never have looked very satisfactory. The font is from about the same date; it's rude, almost primeval, and depicts, most strangely, four mermen holding up their bifurcated tails, creating a compelling visual rhythm and looking as if they're forming a protective barrier. (There's another very similar font about 20 miles away in St Peter's, Cambridge.) Today we're comfortable with the idea that figures from folklore, or even pagan mythology, have found their way into churches, but in earlier centuries when some people looked at this font they saw men grasping the prow of a boat, symbolising the Ark or the waters of baptism. And who's to say that they're not correct? We'll never know the intentions of the masons who made it or the men who paid for it.

The chancel and transepts, of the late thirteenth century, are on the cusp of the Early English and Decorated styles. Internally, the chancel windows are shafted, and externally the transept diagonal buttresses are at their lower stages semi-circular, a most elegant conceit. The nave arcades, with their unusual segmental arches, are early fourteenth century; the quatrefoil piers are entirely typical of their date.

There are some entertaining misericords, including two men who seem to be shaking their fists at each other, oak leaves (very reminiscent of the National Trust logo), and a lively head with tongue sticking out, furrowed brow, and eyes looking off to their right. Some grotesques seem designed to look alarming (sometimes comically so), but this one seems more alarmed than alarming.

A window from 2000 in the south aisle sends a bomb burst of colour reverberating around the otherwise mostly monochrome church. It's by Patrick Reyntiens and is a memorial to the American airmen who were stationed at nearby Nuthampstead airbase from April 1944 to June 1945. They flew B-17 Flying

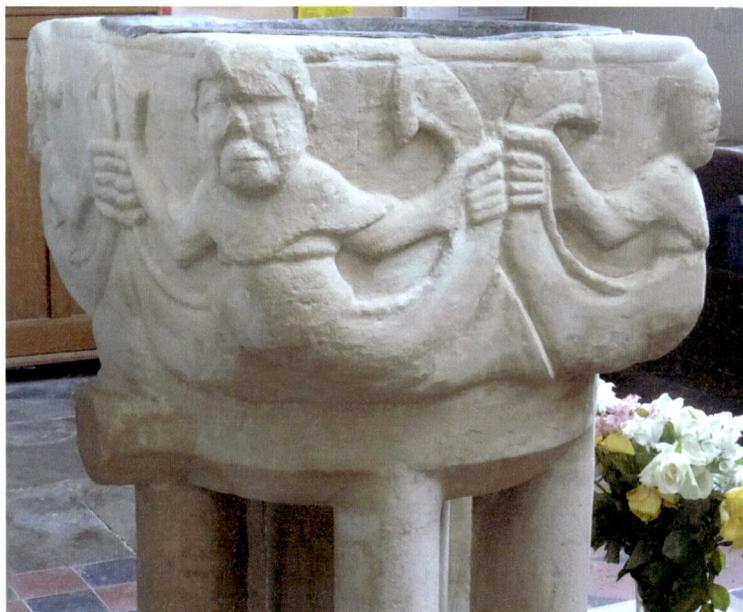

Above and left:
Anstey.

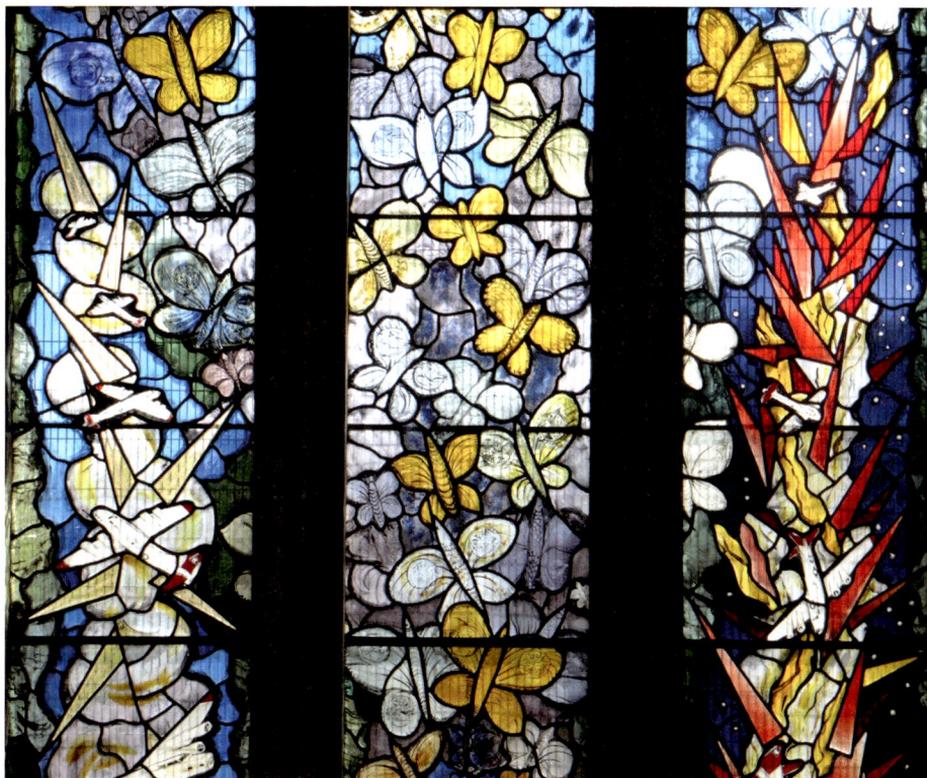

Anstey window by Reyntiens, 2000.

Fortress bombers; 293 lost their lives doing so, and their names are inscribed on the wings of numerous butterflies (symbols of the soul). These, together with birds (at the top of each light), ascend, as do the planes on the left as they make height in preparation for crossing the Channel and attacking Germany. But the planes on the right fall, two of them at horribly vertiginous angles from which they'll very likely not recover. The shard-like triangles of red and yellow suggest the searchlights and the explosions of shrapnel from the anti-aircraft gunfire, both of which malevolently hunt the planes. The right light evokes horror, death and destruction, while that in the centre offers solace by suggesting hope in an afterlife. (Only a dozen miles away, the last flying B-17 in Europe is based at Duxford.)

3. ARDELEY, ST LAWRENCE

At first the church looks to be typical Hertfordshire Perp'n'flint, but as so often this is only partly true: inside its thirteenth-century origins are apparent, and the fourteenth contributed too. The monument (sometimes attributed to William Stanton) to Mary Markham, who died in childbirth in 1673, aged twenty-four, is more than usually moving. She is expensively dressed with puffy sleeves and wears a no doubt costly necklace, but has bare forearms. She looks off into the distance; it's hard to read her expression, but it seems to combine noble stoicism

and profound suffering. No sentimentality here; the very lack of outward emotion is what makes it so emotional. Her left-hand clutches her dress to her chest protectively. Somehow the delicate gesture in which her little finger is separate from the others is very affecting. We learn from the inscription that she 'had issue one son deceased'; her swaddled baby is on the ledge in front of her.

In such tragic circumstances it seems almost impious to take pleasure in the exquisite lettering (note the graceful curls on many of the capitals, and the way the two 'f's in the last two lines (excluding the date) link). The carver felt free to vary the way he cut the letters; compare the 'u' in 'Daughter' with that in 'issue', for example. We can also note in passing that punctuation doesn't seem to have been thought necessary.

The richly carved Arts and Crafty rood loft is from 1928, by F. C. Eden (who also designed the Arcadian thatched cottages, Tuscan porticoed village hall and brick well house on the green opposite the church). Notice the small Instruments of the Passion at the tops of the arches just beneath the rood, where we'd normally expect to find tracery.

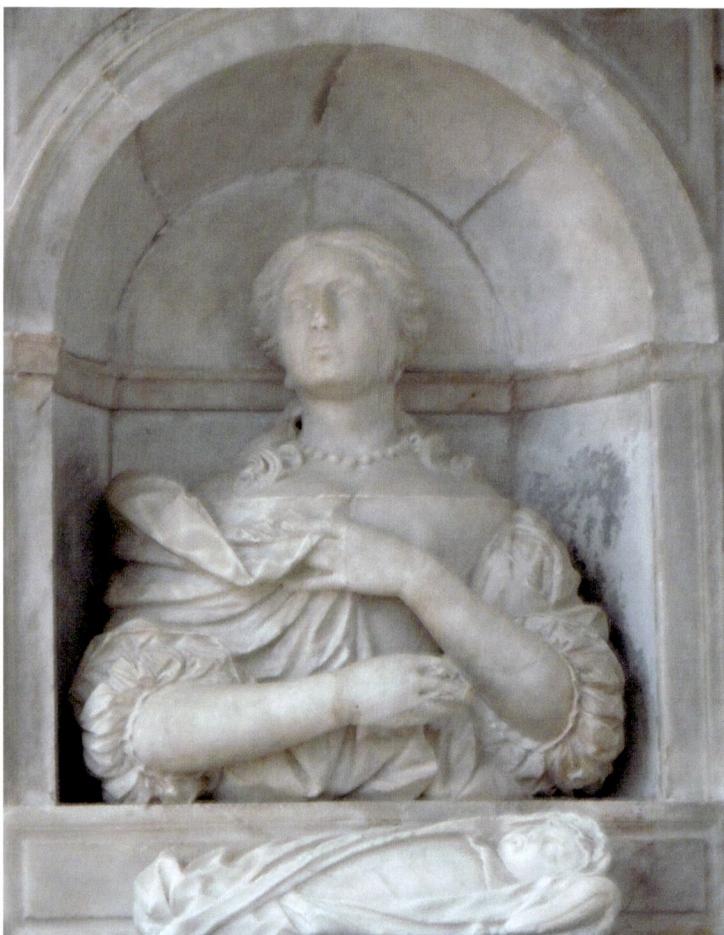

Ardeley.

4. ASHWELL, ST MARY

The sudden appearance of Ashwell church tower, set against the plains of Cambridgeshire, as the hill is crested on the roads from Newnham or Bygrave is one of the great sights of Hertfordshire. It is by some distance the tallest and grandest of any medieval parish church in the county; it dates from the mid-fourteenth century and is built of clunch, the softness of which perhaps necessitated the large and inelegant angle buttresses. (In places the stone now looks pockmarked, as if it's crumbling like Cheshire cheese.) This clumsiness is compensated for by the slender spike at the top, far more ambitious and graceful than all others, sitting as it does on a tall octagonal drum with small pinnacles and even tiny decorative flying buttresses.

Enter through the two-storey, later fifteenth-century south porch and we are in the spacious and light-filled nave. Stand in the doorway and look up and slightly

Ashwell.

to the right to find a very combative label stop, a man with clenched fists and angry expression obviously looking to thump visitors. A very strange sort of greeting. (There's a similar welcome in nearby Rushden.)

Churches were built from east to west, so the chancel would have come first, hence the delicate crocketed and finialed sedilia and piscina under their ogee arches, standard features of the Decorated style of the first half of the fourteenth century. The piers in the east are of the usual rounded quatrefoil shape of the period, but it is enlightening to observe the stylistic changes as work progressed. Those in the west have more straight lines than curves, and by the time the junction with the tower is reached the Perpendicular style has well and truly arrived, as witnessed by the gargantuan blank tracery panels which uncompromisingly emphasise the vertical.

Inside the base of the tower are the famous graffiti, which alone would make a visit worthwhile. The inscriptions are in (apparently ungrammatical) Latin and a hard to read script, but one records the arrival of the Black Death in the village in June 1349 (a year after it had first reached England). About a third of the country was wiped out. It's possible to have an inkling of the horrors that ensued from a graffito from 1361: 'a pitiable, fierce violent (plague departed); a wretched populace survives to witness and in the end a mighty wind, Maurus, thunders'. It must have felt as if the last days were upon them.

There's also a detailed picture of Old St Paul's Cathedral, London, which burnt down in the Great Fire of 1666, and, four stones to the left, another spired church. What's more, there are dozens of other graffiti, especially on the south arcade.

It's tempting to think that the Black Death caused the transition from Decorated to Perpendicular; afterwards it must have seemed frivolous and impious to indulge in architectural fripperies, and there's something penitential about Perpendicular. Compare the lovely carefree curvaceous Decorated east window of the north aisle with the other windows in the church, which are mostly unlovely utilitarian Perpendicular grids. However, this is probably too simplistic an explanation; the Great Famine of 1315–17 wasn't much less destructive than the plague, killing more than one in ten, and Decorated survived that.

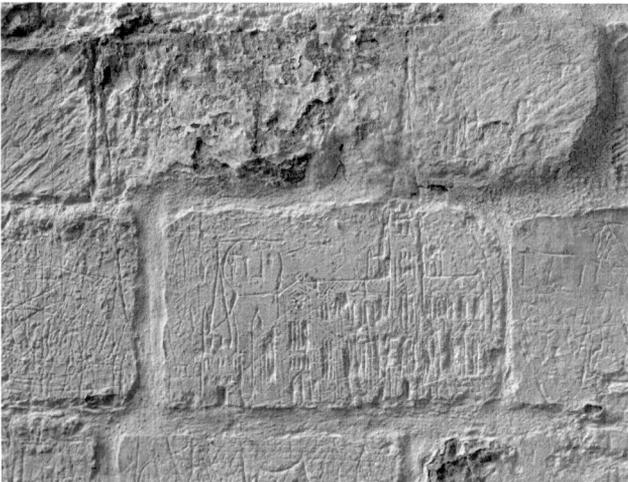

Ashwell.

5. AYOT ST LAWRENCE, ST LAWRENCE

The church of Ayot St Lawrence, built in 1778–79, was revolutionary in its day. Some churches in England had been designed using classical elements since the 1630s, not least Wren's fifty or so in the City of London, but they relied chiefly on Roman models (ancient and modern). Palladianism was very fashionable in eighteenth-century England, but this too was chiefly inspired by classical Roman architecture. Ayot St Lawrence was the first church – almost the first building of any sort – in England to go back to the Greeks for inspiration.

Sir Lionel Lyde of Ayot House had made his fortune by importing tobacco, grown by means of slave labour, from the West Indies and Virginia, and spent some of his ill-gotten wealth by building a new parish church which would serve the triple purpose of place of worship, mausoleum and eyecatcher when seen from his house. He employed Nicholas Revett to design it, one of only four complete buildings Revett was responsible for. Being a gentleman of private means, he didn't need to work for a living, but spent much of his time studying and publishing about classical Greek architecture. He used elements from several Greek buildings in his design; for example, the Doric columns of the portico are based on those of the Temple of Apollo, Delos (426 BCE). However, in the interior there are details drawn from Roman models; for example, the hexagonal and octagonal coffering of some of the ceilings is taken from the Temple of Peace in Rome (71 CE), and the overall conception of the (liturgical) west front (which actually faces east, so as to be seen from the house) is entirely Palladian. (Originally the two outer pavilions were crowned by tempietti, small round towers, but these were removed by 1819.)

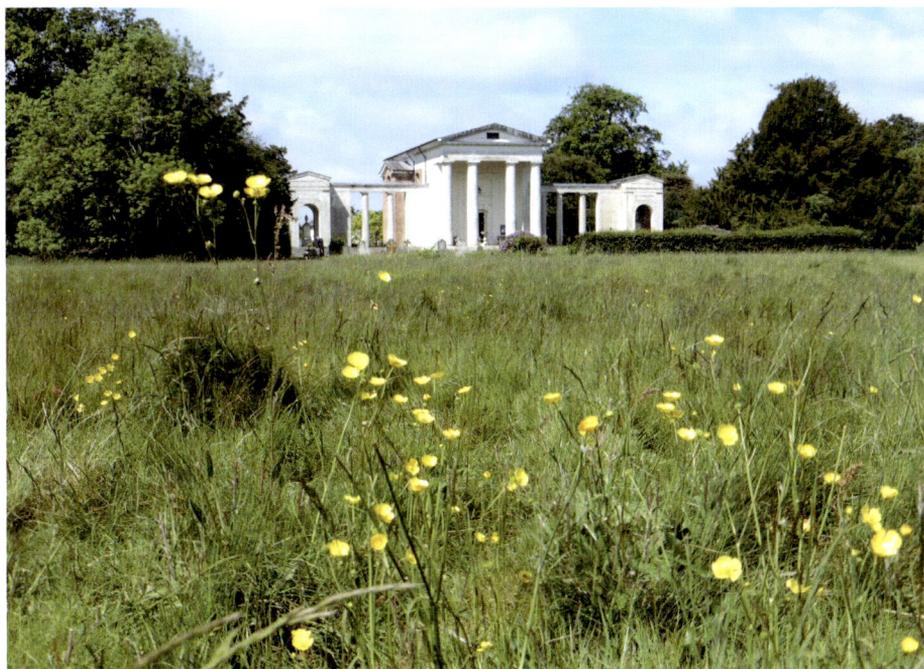

Ayot St Lawrence.

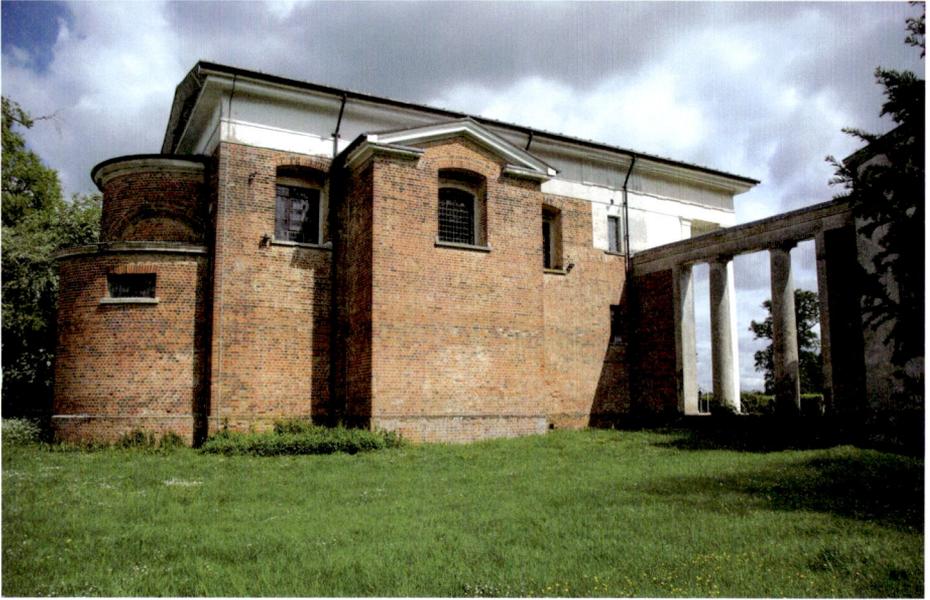

Above and left: Ayot St Lawrence.

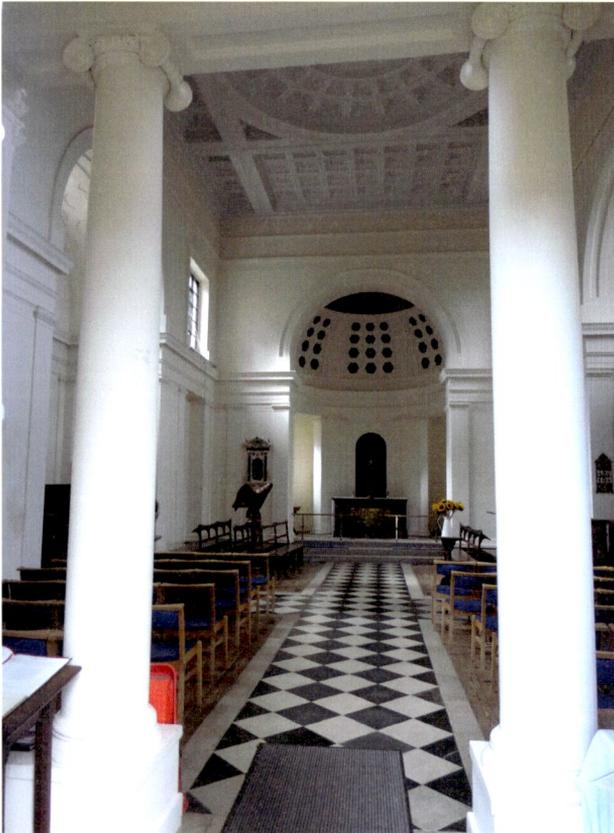

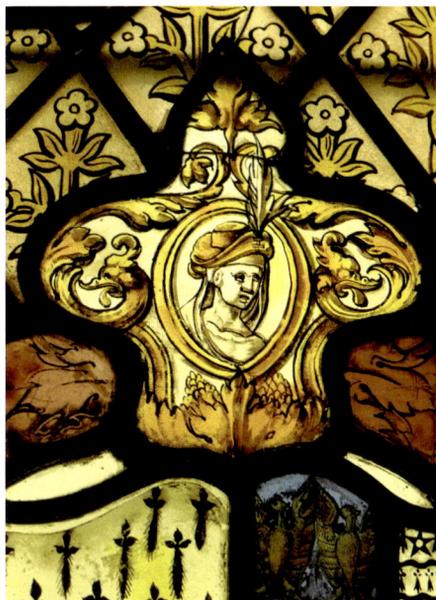

Ayot St Lawrence.

But to add to the mixture, we notice that while the west front is white and looks like stone, which the Greeks would have built with, the bulk of the exterior is of red brick. (In fact the church is mostly not stone but stuccoed brick.) This is at first a disappointment, but over the years I've learnt to particularly like the east end, which consists of a tall apse enclosed by a lower one, only this latter apse has the middle third sliced out of it. This creates complex and intriguing geometries, which change as you walk round. Altogether it looks like a building designed with some industrial process in mind – a blast furnace or a pottery kiln, perhaps. A church in bucolic Hertfordshire transports us to Classical Greece, but also reminds us of the dark satanic mills of the Industrial Revolution which was in full swing when it was built.

In the church is a lightbox which displays some seventeenth-century heraldic glass with eight extremely characterful heads peering wistfully out of fictive round frames, as if out of a galleon's portholes. There are three grey-bearded kings, four much more youthful queens, and a pilgrim with palm leaves in his hat. It came from the old medieval church which stands nearby, an accessible ruin.

6. AYOT ST PETER, ST PETER

J. L. Pearson, the architect of masterpieces such as Truro Cathedral and St Augustine, Kilburn, had little luck in Hertfordshire. He built a church in Ayot St Peter in 1862 which was hit by lightning and mostly destroyed in 1874. He restored only two churches in the county, and had he lived to see one of them (Pirton) hit by a V1 flying bomb in 1944 he could have been forgiven for thinking that the *genius loci* had it in for him.

Salt was rubbed in the wound when his bid for the contract to rebuild after the lightning strike was rejected (but he claimed £5 19s 3d (£543 today) for visiting the site). Instead the job went to J. P. Seddon, who built a minor masterpiece of his

own in 1874–75, an early and important exemplar of the genesis of the Art and Crafts movement.

It's built of red brick enlivened by patterns picked out in white and blue ones, the chancel being the most elaborately decorated part. There's an apse with no fewer than nine lancet windows; most of the other windows are cusped lancets, but there are also three sexfoiled rose windows, including one on the beautifully composed west front. The stone broach spire is, unusually, placed at the east end of the south of the nave; it boasts a clock, the face of which is predominantly blue, by prolific mosaicist Jesse Rust of Battersea (who supplied buildings ranging from churches to university buildings and hotels to lavatories).

The interior is entirely enchanting. The font is decorated with another Rust mosaic, of fish swimming cheerfully through water lilies, with mannered ripples and waves. There's a complete set of contemporary stained-glass windows, many designed by Seddon himself, for example that depicting David strumming his harp while songbirds warble an accompaniment and sheep provide an appreciative audience.

However, it's the chancel that packs the biggest aesthetic punch. The chancel arch is, uniquely so far as I know, of glazed stoneware, with more birds perched on the corbels, and there's a screen of curly wrought iron. The wooden ceiling is painted with saints, angels and the symbols of the four Evangelists, while the

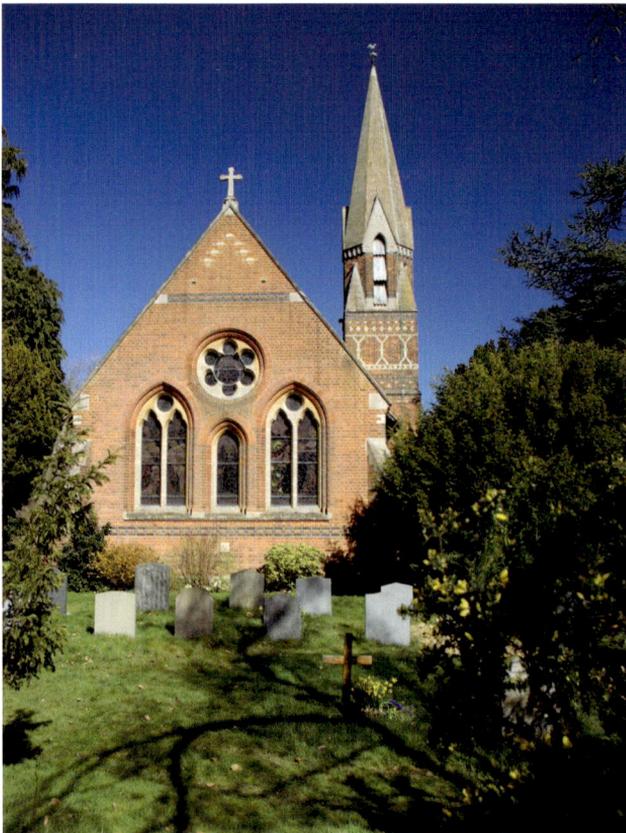

Ayot St Peter.

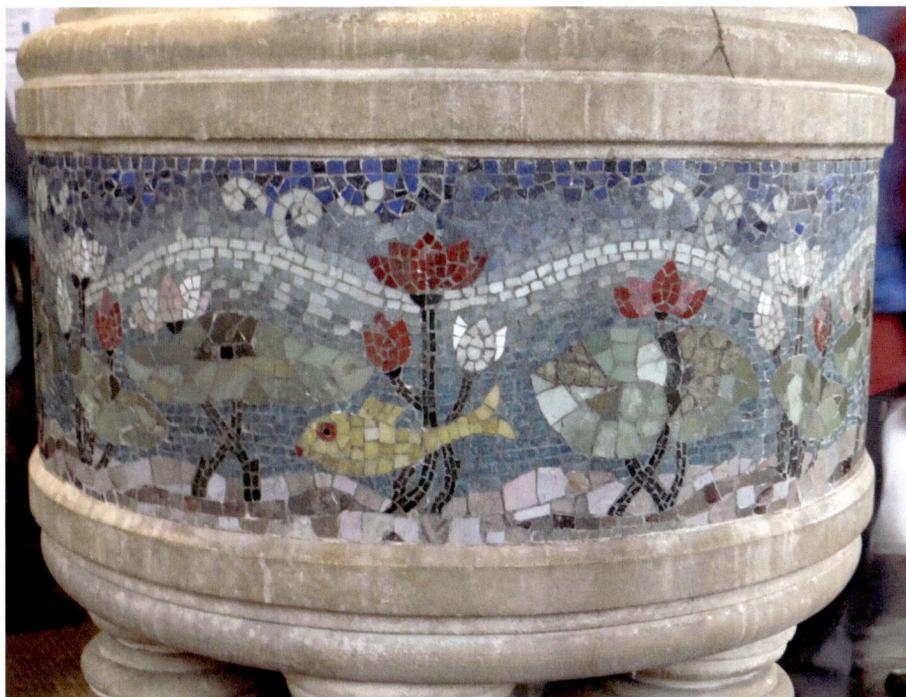

Above and right: Ayot St Peter.

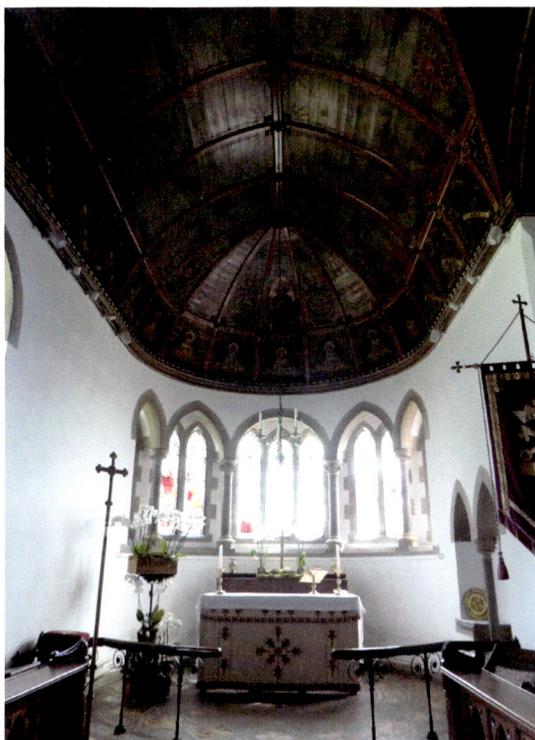

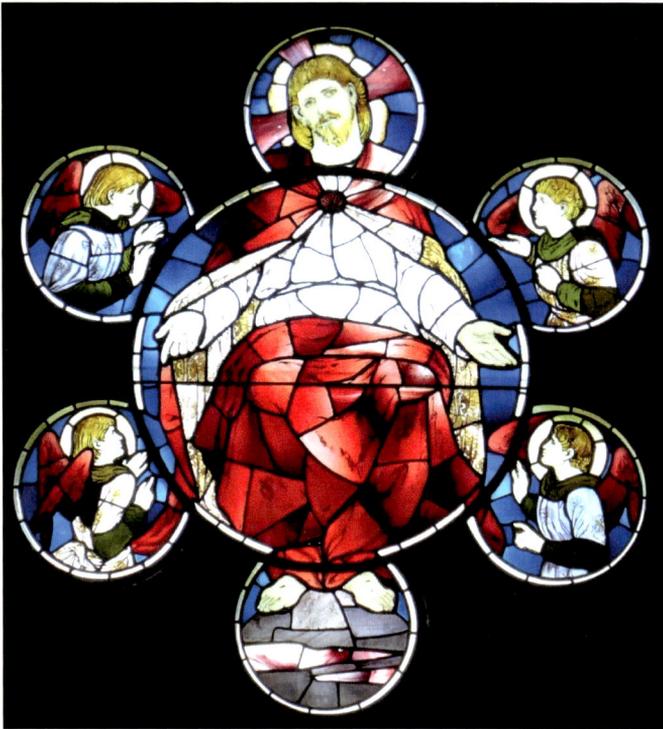

Ayot St Peter window
by Seddon, 1880.

circular floor of the apse, the altar rails curving nicely to fit, has more Rust mosaics and brown and pale gold encaustic tiles by William Godwin of Herefordshire. It's the best and most complete Arts and Crafts church in the county (but Woolmer Green is also worth a visit).

7. BALDOCK, ST MARY THE VIRGIN

Externally mostly Perp'n'flint, much rebuilt by the Victorians, St Mary the Virgin is essentially a grand Decorated building of *c*. 1330. The recently restored tower has a spike mounted on an octagonal drum, a simplified version of that of nearby Ashwell.

Inside we find eight bays of stately quatrefoil arcading, an impressive sight. There are three screens, extending over the whole width of the church, and for my money they're its highlight. The chancel and north chapel screens are from the late fourteenth century; their rectilinear design (especially of the latter) announces that the Perpendicular style had really taken hold by this time. Some curious figures prowl in the spandrels of the dado; weirdly, a large fish is about to swallow, or bite the head off, a mermaid. In medieval Christianity mermaids were generally used as symbols of vanity and seen as temptresses who lured men away from righteous living. A common symbol of Christ was a fish, so a glib explanation of this carving would be that it shows Christ defeating evil. However, as the fish is so monstrous-looking I find it hard to accept this theory. I can't offer a better one, though.

The south chapel screen is from the fifteenth century. It has a glorious elaborate canopy; I especially like the vine snaking along the cornice at the top, and notice

that in the arch of each of the eight lights there is extra cusping, independent of the tracery, and that the arch of the doorway is topped by a twisted stem moulding from which crockets spring.

The east window is by William Wailes (1847), an excellent early Victorian work; the hieratic main figures with their towering intricate canopies contrast with the movement of the small scenes, all bound together by the liberal use of colour (especially the brilliant blues and ravishing reds). The kneejerk criticism of Wailes is that his colours are like boiled sweets, to which my reply is: what's wrong with looking like boiled sweets?

The north porch dates from 1836, when ecclesiastical architecture was moving away from the eighteenth-century Gothick style, which used exaggerated versions of some medieval features, towards the Gothic Revival, which tried to be more faithful to the original models. The porch is an interesting transitional piece. Externally it's convincingly based on late medieval models, while inside it has an enchantingly artificial plaster vault. The corbels have heads over which mini-monsters crawl, and in two cases viciously attack them, creating quite disturbing scenes. What on earth is this supposed to be all about? The bosses have, in contrast, rather cute wyverns. One of them hisses at the viewer, but we're not convinced he's a threat. I'm sure that a nice tickle behind the ears would have him purring (or whatever noise a contented wyvern makes) in no time.

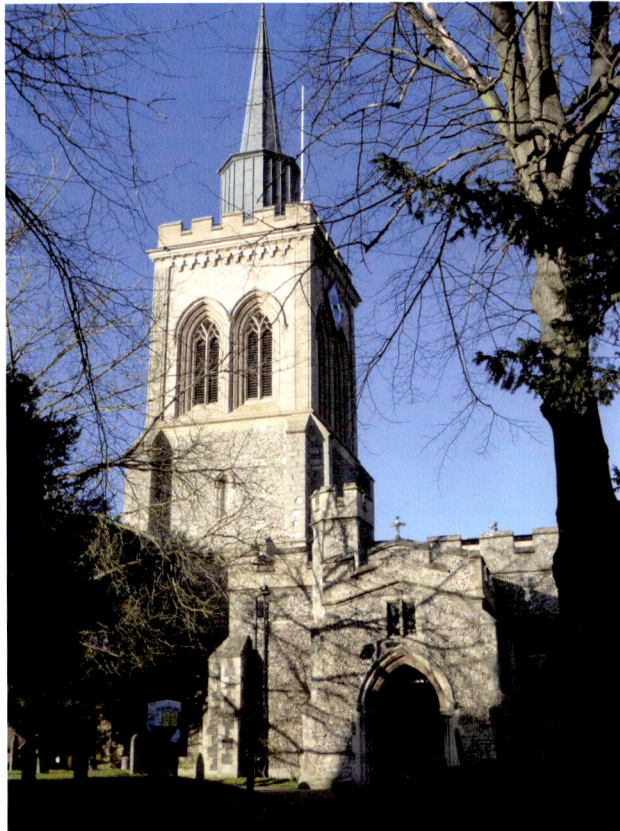

Baldock.

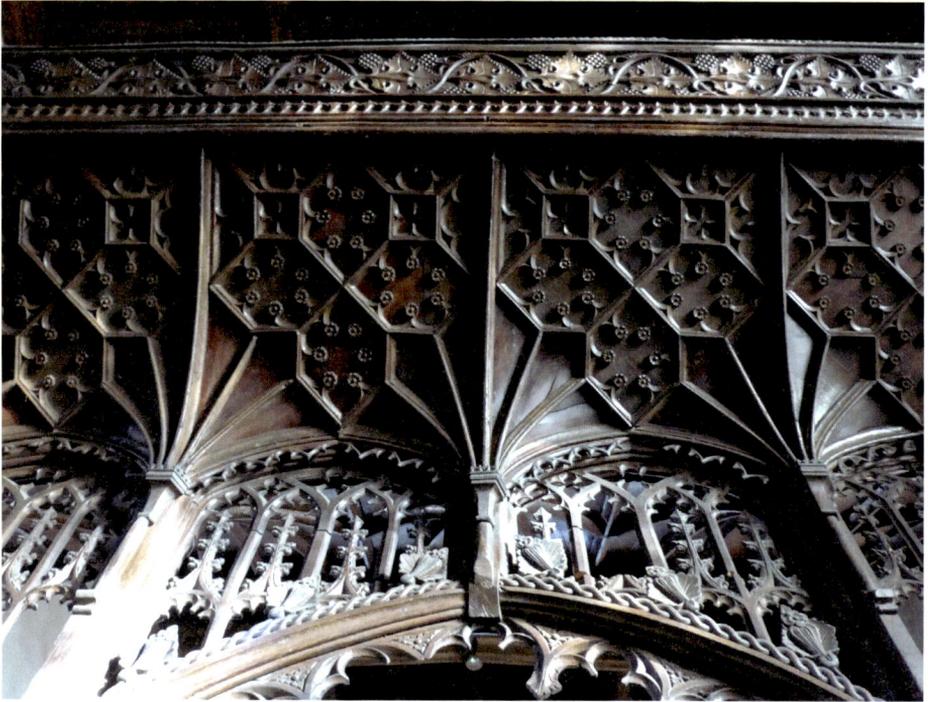

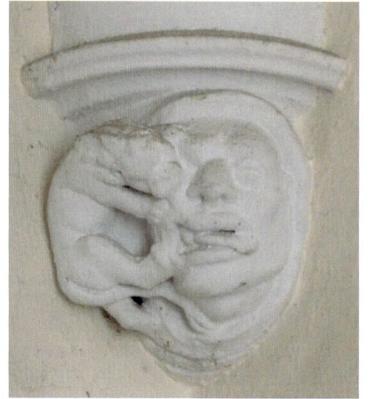

Top, left and above: Baldock.

8. BEDMOND, ASCENSION

In the mid-nineteenth century, with rapidly growing towns, there was a pressing need for new churches. Thanks to the newly invented corrugated iron, prefabricated buildings known as 'tin tabernacles' were a quick and convenient way of meeting this. There are about eighty left in the country. Bedmond's example dates from 1880 and cost the remarkably small sum of £80 (£7,763 today); like many of the others it's a minimalistic version of Gothic. Its original builders presumably expected it to be temporary, but here it is, almost a century and a half later.

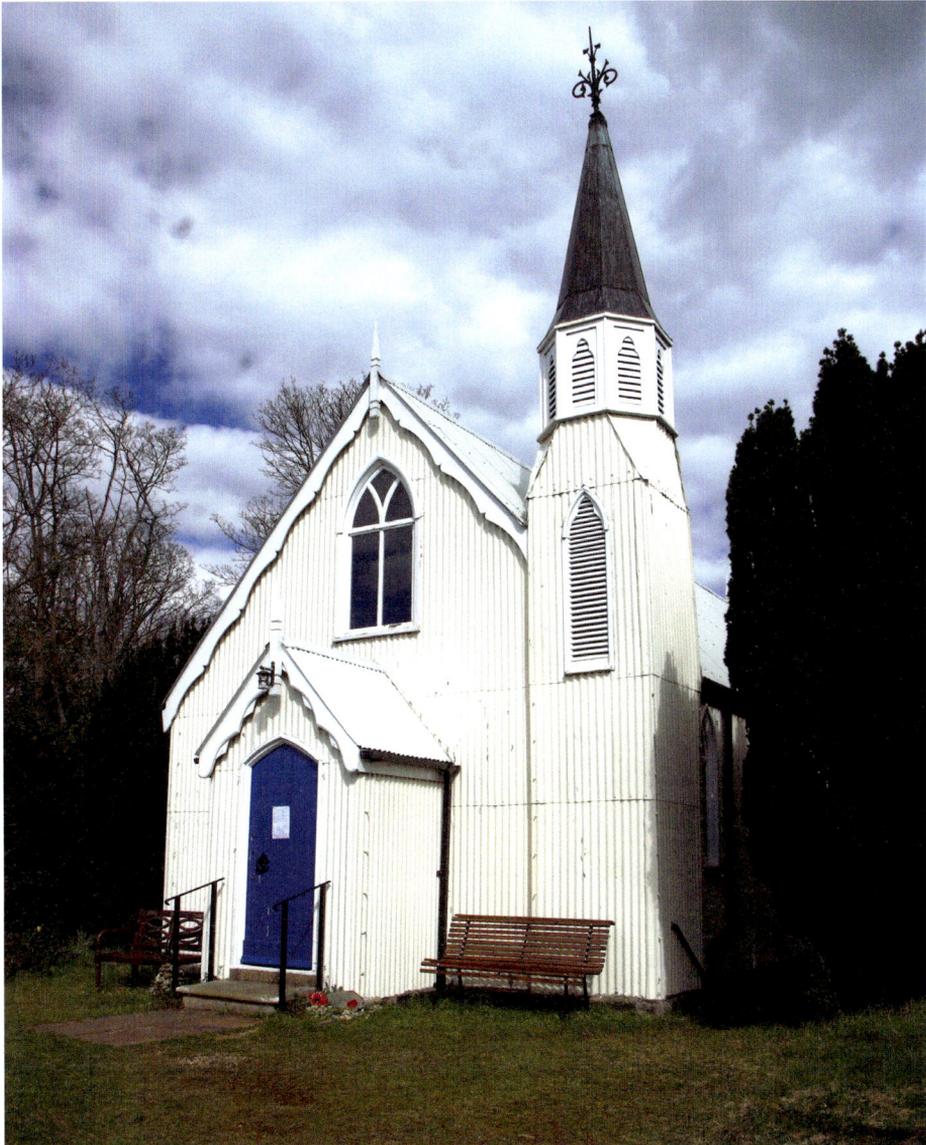

Bedmond.

9. BENGEO, ST LEONARD

This small, humble but mightily atmospheric building is Hertfordshire's only intact Norman village church; most of the windows are of various later medieval dates, the brick porch is Georgian and the roofs and wooden bellcote Victorian, but otherwise the structure is substantially as it was in the twelfth century. The chancel is apsidal (like that of Great Wymondley and Great Amwell). The pewless interior is light and spacious; the plain chancel arch has a crude head of a man, like a child's drawing, on the north capital.

Bengeo is the home of the most emotive medieval mural in a parish church in Hertfordshire. It depicts the Deposition from the Cross, and dates from the thirteenth century. (It was discovered under layers of paint and plaster as recently as 1938.) Joseph of Arimathea, wearing a kippah, and with apparently downcast eyes, lifts down the limp and lifeless body of Christ; he stands on a little hillock, representing Golgotha. Mary tenderly grasps her son's wrecked right hand with both of hers. She looks stunned into disbelieving, catatonic silence. On the right a young figure, probably St John, is using a pair of pliers to extract the nail from Christ's left palm. He isn't looking at what he's doing, maybe too overcome to do so. Instead he looks over his shoulder at another haloed figure, probably Nicodemus, who, sinisterly, seems to have two left hands. It's all faded and faint, yet the rawness of the emotion is fresh. Nothing is overstated; the artist deemed it sufficient to simply lay the events before us; he was right.

Bengeo.

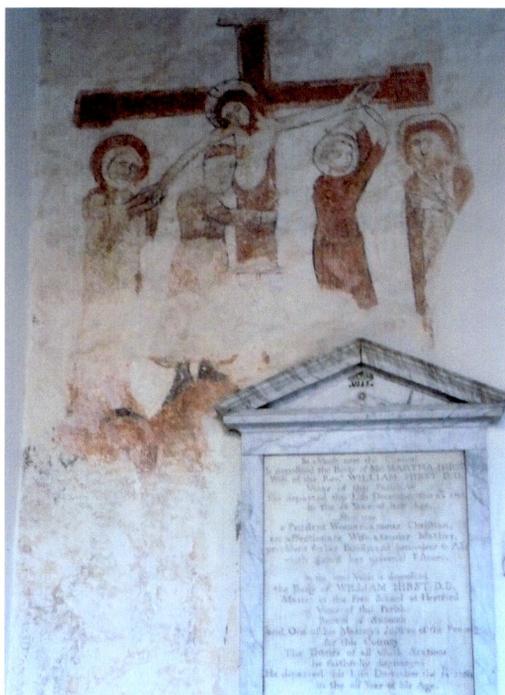

Bengeo.

10. BENINGTON, ST PETER

A fine sight, especially in the spring when the churchyard is thronged with daffodils. The church's origins are thirteenth century – see the stiff-leaf capitals of the piscina – and the tower is from the fifteenth, but most of it is fourteenth-century Decorated. The aisleless nave is tall and clerestoried, but most of the interest is concentrated in the chancel and north chapel. There are two grand tombs (though all the effigies are damaged). One (*c.* 1330) is canopied by an elaborately moulded arch, with crockets, finials and flanking pinnacles, and, at its apex, a sudden little upward swoosh to form an ogee curve. The husband is shown in the act of pulling his sword from his scabbard, and has his legs crossed; incidentally, there is no truth in the old tale that this indicates a crusader – it was simply an artistic fashion designed to give animation to the figure. The other tomb, next to the altar, was made a century later than the first.

The fifteenth-century corbels in the nave (probably by the same hand that made those at nearby Aston) are appealingly and amusingly rustic, but other carvings in the church are more sophisticated. The earlier tomb has a number of notable label stops; there's what could well be a portrait of the dead knight, more naturalistic than most busts of the period, suggesting an aristocratic hauteur but also sensitivity, and a king whose body has been pierced by a sword. Is he struggling to remove it, In which case he could be Edward II (assassinated shortly before), or has he stabbed himself (in which case he could represent the sins of accidie – listlessness or apathy, which could lead to suicide – or wrath)? Either way, it seems a strange thing to have on a tomb.

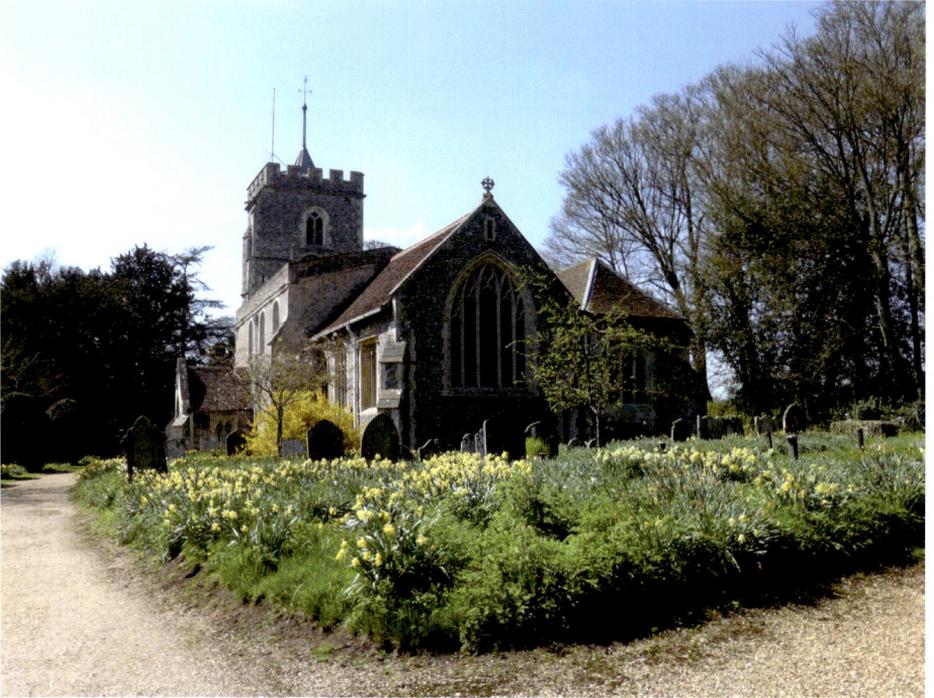

Above, below and opposite: Benington.

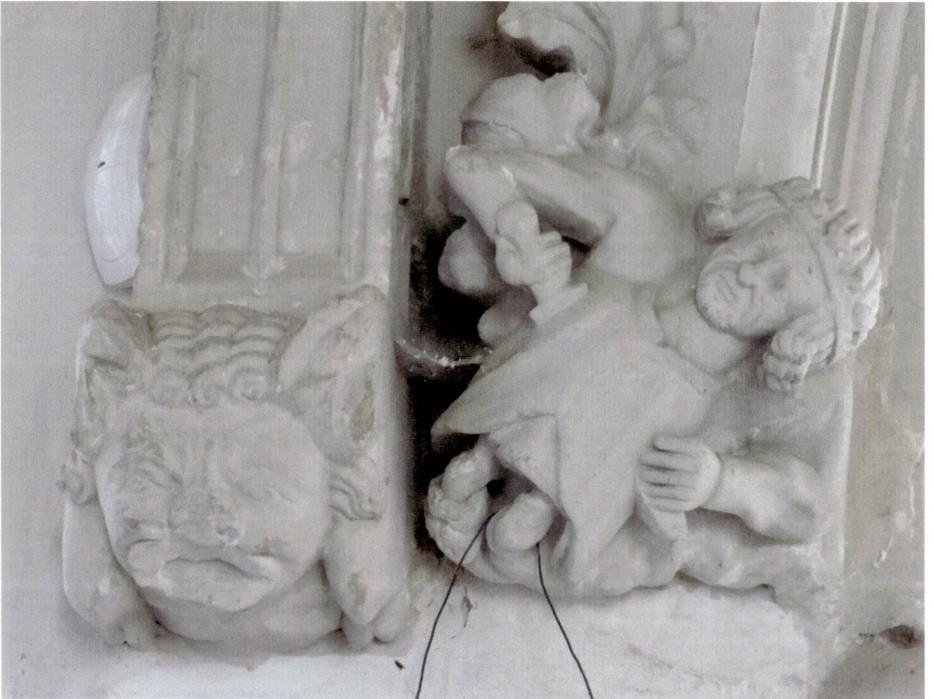

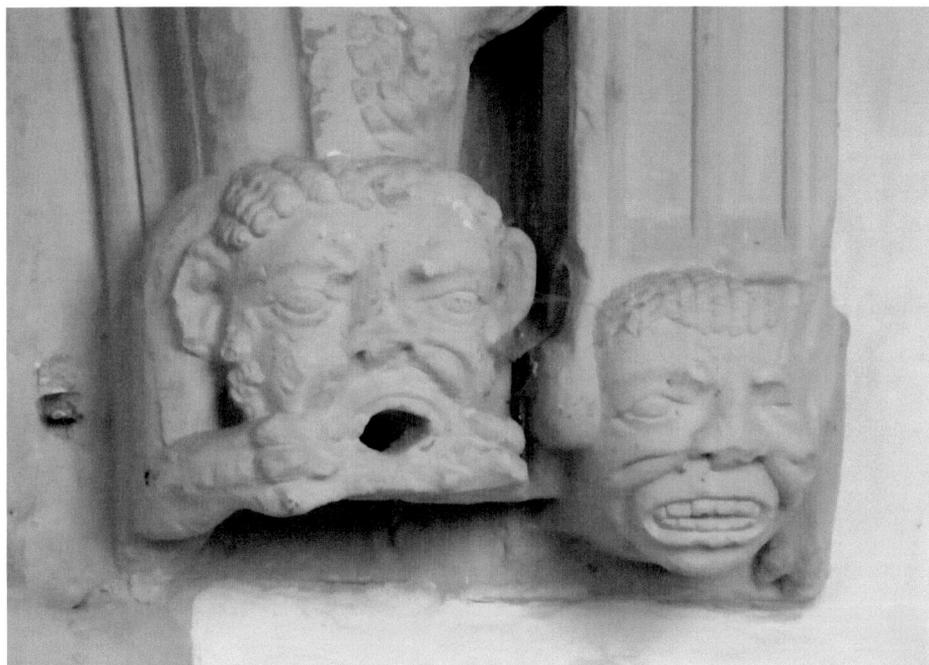

Even stranger, perhaps, are the two faces which gurn out across the chancel, one a mouth-puller, the other fiercely grimacing. It seems odd to us that a dignified tomb in the holiest part of the church should be decorated like this, but such juxtapositions are so common in medieval art that we must assume that no contradiction was seen between the sacred and the (apparently) profane. (There's another mouth-puller elsewhere in the chancel.) Similarly, next to the pulpit is a bracket on which once stood a statue of a saint, the underside of which reveals a caricature-like figure of a not-very-holy-looking crouching man wearing a coat with four big buttons.

In the porch there's an endearing window (1994) by Alfred Fisher, featuring painting and gardening implements, a bee, snowdrops and – which is where we came in – daffodils.

11. BERKHAMSTED, ST PETER
Berkhamsted church is large and imposing with its tall central tower and transepts, but, externally, isn't easy to love. It suffers from having traffic running almost alongside its south side, and buildings crowd it on the west. However, inside there's much to reward the visitor.

The core of the church is thirteenth century. Surprisingly, the east of the north transept opens out into a two-bay vaulted chapel. Built, like the crossing and transept itself, *c.* 1230, this creates the kind of thrilling spatial sensation that would normally be found only in much larger churches.

Since the reign of Henry VIII it's been common to display the arms of the monarch in churches. However, the arms of Tudor monarchs are rare, there being

probably only a dozen or so in the whole country, so Berkhamsted is fortunate to have those of Elizabeth I. Unlike most such arms, which are square- or lozenge-shaped, these are rectangular with an oval bulge at the bottom and contain a fictive tondo and swags.

There are several excellent Victorian stained-glass windows (and an enjoyable modern engraved one), mostly by two of the most prominent firms of the era, Clayton & Bell and Heaton, Butler & Bayne, most of which avoid the sentimentality that mars so many of this period. The big west window is an example of the work of the latter firm, from 1867. Unusually, we know the name of the designer, Alfred Hassam. In about 1864 he became the chief designer of Heaton, Butler & Bayne, aged only twenty-one or twenty-two, a precocious achievement. He also exhibited at the Royal Academy. However, he died of tuberculosis in 1869, aged twenty-seven.

There are ten main scenes, most of which are associated with St Peter; for example, the second light from the right, top row, shows Christ addressing three male saints, with (probably) Peter, with a monastic tonsure, at the bottom, and

Berkhamsted.

a sailing ship in the background, referring to Christ calling him to be a 'fisher of men'. Hassam has obviously much relished drawing the rigging and snaking banner at the top, and even the stones and shells at the bottom are lovingly depicted. Gruesome deaths feature strongly in the window with five martyrdoms placed around the extremities. The design is very busy, perhaps too much so, the details not easy to appreciate from a distance, yet overall it succeeds marvellously. Hassam's use of colour is striking, and each panel is worth studying to see how skilfully composed it is. What a shame that the firing, in which the black or dark brown painted on the glass is fused with it, wasn't up to the job, as many faces have badly faded.

The south window of the south transept is very different, being much more closely based on medieval precedents, but just as good. It's by Clayton & Bell, from 1872, and depicts the Day of Judgement. The vivid colours and the skilful massing of the numerous figures are very effective. As in most Victorian representations of

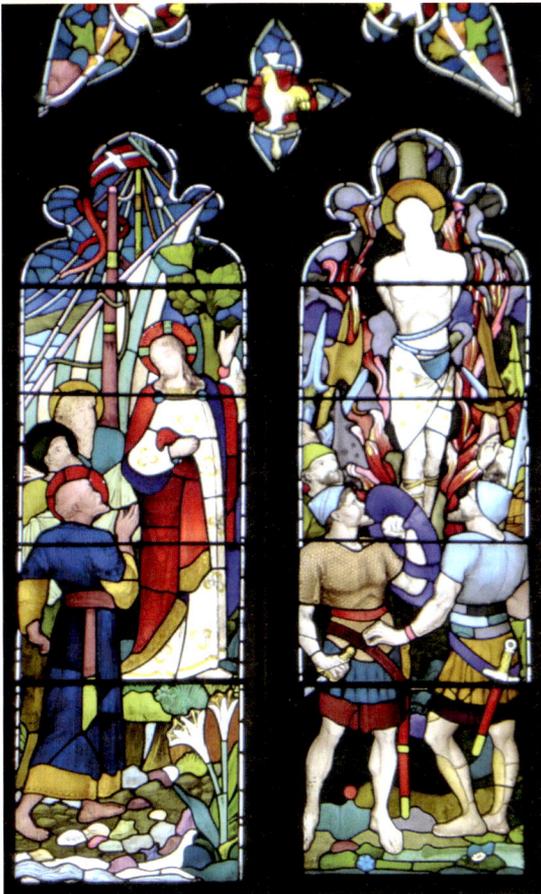

Above left: Berkhamsted window by Heaton, Butler & Bayne, 1867.

Above right: Berkhamsted window by Clayton & Bell, 1872.

the Last Judgement, there's no sign of any judging taking place. At the bottom of each panel people emerge from their graves but the atmosphere, set by a dozen vigorously trumpeting angels, is celebratory. They're clearly all going to Heaven; Hell doesn't appear to be an option, unlike in medieval Dooms where the agony of the damned is depicted with relish. (Clayton & Bell were also responsible for the Renaissance-style Last Judgement window in King's College Chapel, Cambridge (1879), which does show the damned in order to conform to its historic context. There's another, sadly feeble, one in Baldock (1880).)

12. BISHOP'S STORTFORD, ST MICHAEL

There's plenty to see here (but note that as you enter you're being seen by the all-seeing eye of God in the left spandrel of the south door). The church is mostly fifteenth century, hence the mercilessly repetitive and dull Perpendicular window tracery. But I must admit the masons made a good job of the high and dignified nave arcades.

The outstanding features are the misericords, the corbels and label stops. There are eighteen of the former, the best collection in the county (it's rumoured that they came from Old St Paul's Cathedral at the Reformation). There are women and men (two of them turbaned), a wyvern, the eagle of St John, angels, an owl, a swan, and, perhaps most interesting of all, a serra, a mythical beast based on the sailfish or sawfish. This was believed to be a gigantic fish with huge fins, which it used as sails in attempts to catch ships.

Many of the corbels aren't just heads but half-length genre figures, brandishing various tools and objects (some of them easy to identify, some more puzzling). For example, there's a mason with his chisel (a self-portrait?), a woodman with his axe, and a soldier with sword and buckler. Together they comprise a fascinating gallery

Bishop's Stortford.

of fifteenth-century life. Among them are also some grotesques and monsters. Most of them are carved with more attention to detail than was often allotted to such out of the way statuary; we can only guess why the masons lavished so much attention on them, but are glad that they did so.

13. BRENT PELHAM, ST MARY

This essentially mid-fourteenth-century church (see the tracery on the original south door) is the last resting place of a dragon slayer. His name was O. Piers Shonks. He died in 1086 and his tomb is in the north wall of the nave. A dragon was terrorising the district, and Shonks, the lord of the manor and a giant, managed to fatally stab it. However, as it happened this particular dragon had

Brent Pelham.

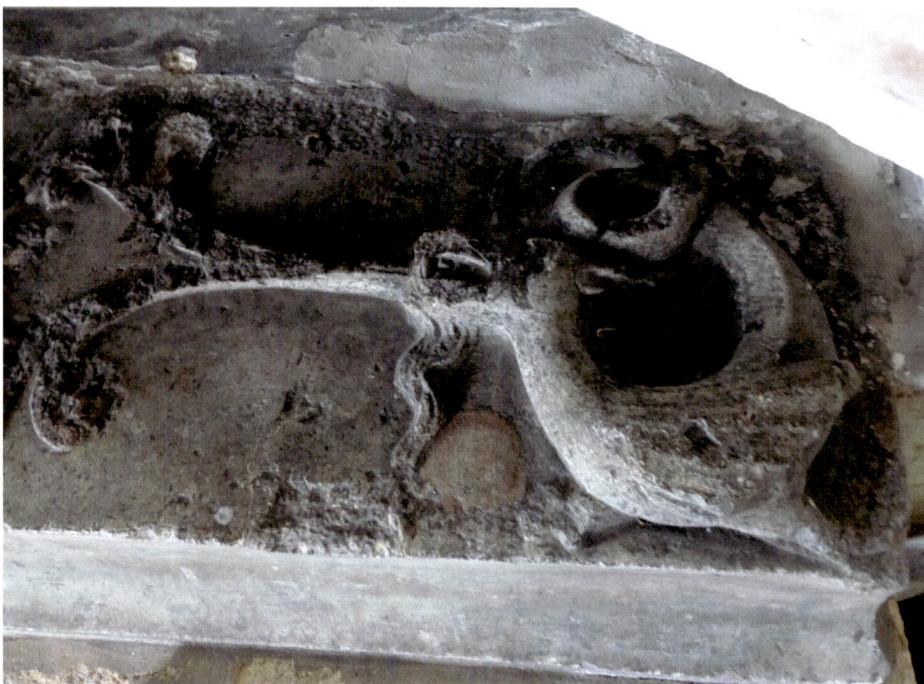

Brent Pelham.

been a special favourite of the Devil, who was furious at Shonks. (A Devil who has a favourite dragon sounds at least a little sympathetic.) The Devil told Shonks that he would get his revenge by taking his body and soul when he died, whether or not he was buried in a church. Many years later, when he was on his (unusually large) deathbed, Shonks fired an arrow into the air, decreeing that he would be buried wherever it fell. It hit the north wall of the church, and so he was interred within the wall, neither in nor out of the church, and thus safe from Hell.

His tomb is a remarkable object. It is of expensive, highly polished black Purbeck marble and dates from the thirteenth century; an inscription in English and Latin narrates the story. At the top an angel carries a soul to Heaven, surrounded by the symbols of the four Evangelists. In the middle we see a richly foliated cross, and at the bottom the dragon (actually a wyvern as it has two rather than four legs). It throws up its tail, the tip of which is elegantly, even genteelly, curled, and it has a stylish goatee beard (you can sort of see why the Devil was so upset). It's usually assumed that the dragon is depicted in its death agonies, having been stabbed by the shaft of the cross, but this is ambiguous; it's entirely plausible that what looks like a shaft is emerging from (perhaps in the form of stylised flames), not entering the dragon's maw.

It's one of very few church monuments to have had a book written about it, *Hollow Places* by Christopher Hadley, which I highly recommend. Astoundingly, the conclusion he reaches is that the story does have some factual basis (but spoiler alert: there wasn't a literal dragon. Sorry to disappoint).

14. BUNTINGFORD, ST PETER

After the Reformation in the 1530s church building in England came to a virtual standstill. It slowly began to revive in the seventeenth century, and the style adopted was usually not state-of the-art classical, but old-fashioned Gothic, the style of the Middle Ages. The first classical church in England was Inigo Jones' St Paul's, Covent Garden, London, in 1631–63, which did have some influence, but, away from the capital, Gothic remained the default style for about another century (and never entirely disappeared).

This phenomenon is known as the Gothic Survival. It's not much known or studied, presumably because new styles springing up are more exciting than old ones hanging around past their sell-by dates, and no book has ever appeared about it. But nearly every county has a handful of examples, and I find these living fossils fascinating. Surely they deserve attention.

Buntingford church is one example. It was built of brick in 1614–15 by Revd Alexander Strange, and cost £418 13s 8d (about £123,000 today, which sounds a bargain). In plan it is a Greek cross (that is, with four short arms) – not very Gothic. On the other hand it has an apse, and, most importantly, the arches are pointed in a simplified version of the Gothic style. We assume that this was because Strange and the builders simply took it for granted that this was the proper, indeed the only possible way of building a church. Tradition is a very powerful force.

However, here and in other Gothic Survival buildings, while it was thought appropriate to be backward-looking outside, inside they were keen to incorporate some of the latest design features. The beam across the south transept is supported

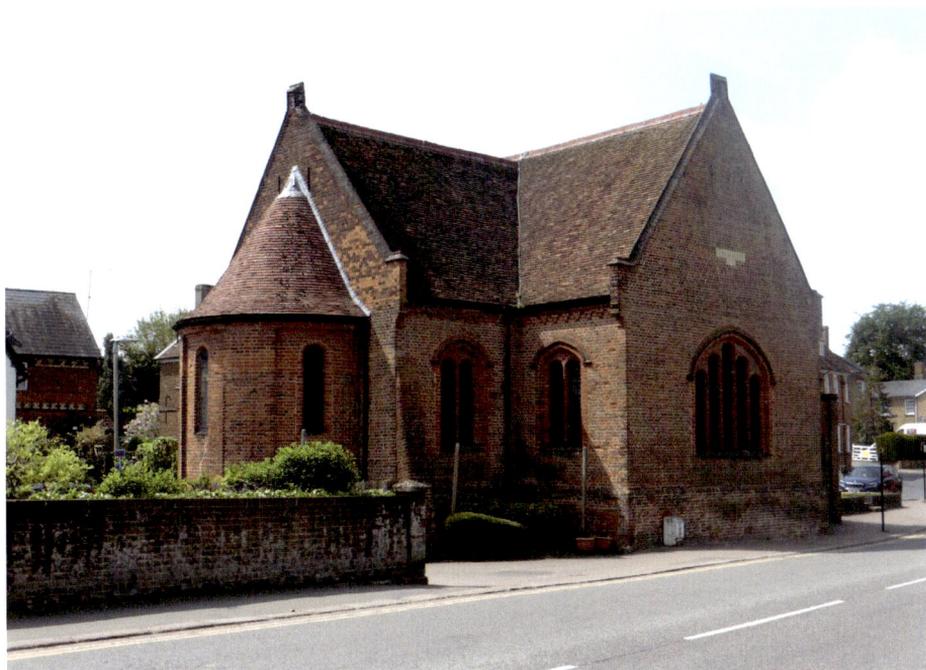

Buntingford.

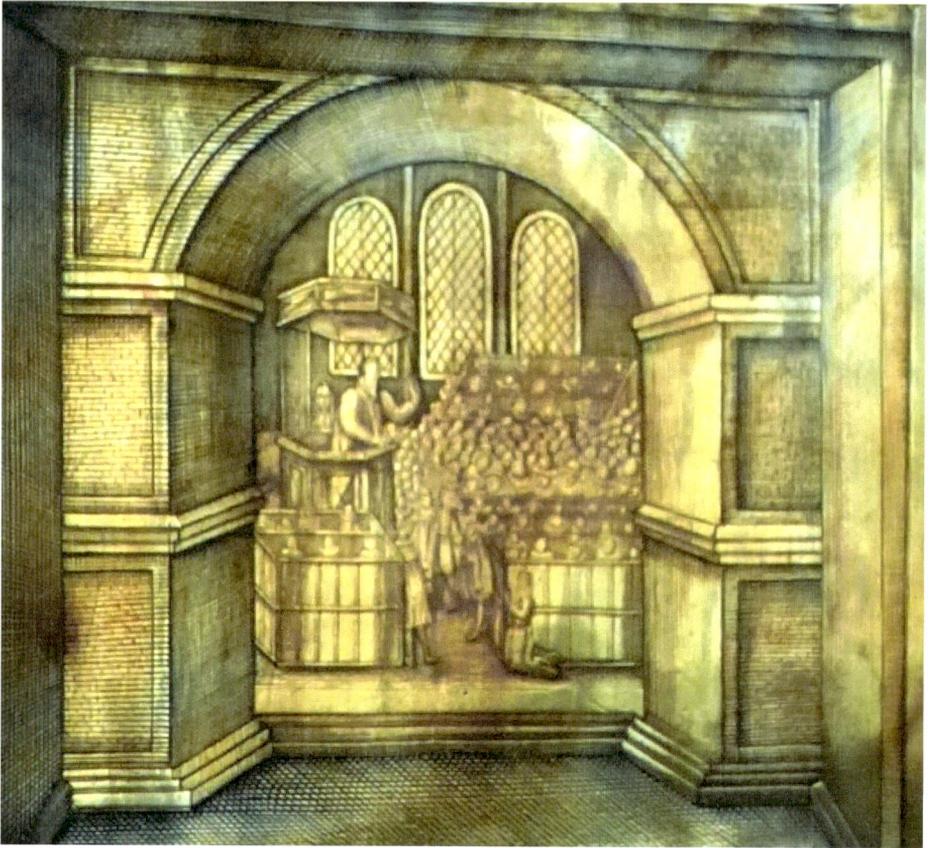

Buntingford.

by two wooden columns, which have Ionic capitals (which are of course a feature of classical architecture). But whoever installed them was clearly not familiar with the style as the volutes are oriented at right angles to the beam, rather than in line with it. This evidence of the workmen's incomprehension of the newfangled fashion is charming.

There's a brass from 1620 which shows a highly idealised view of Strange preaching in his new church. The architectural setting is classical; the large opening through which the scene is revealed looks like a Roman triumphal arch. This adds another layer to the palimpsest of taste: the chapel itself is what we might call minimally Gothic on the outside, but inside has some minimally classical features, while it is depicted on the brass as if it's a grand classical building.

In the brass Strange, at least twice as big as any other figure, stands in his pulpit and gestures passionately. One congregant kneels before him, hands clasped in prayer; a dozen or so, presumably the wealthier and higher status worshippers, sit in the box pews near the pulpit where they have ringside seats and are most visible to the bulk of the congregation. I hesitate to say that this brass is unique, but I know of no others depicting a church service.

15. CALDECOTE, ST MARY MAGDALENE (FRIENDS OF FRIENDLESS CHURCHES)

Caldecote, despite having its own signposted turn off the A1(M), is probably the smallest parish in Hertfordshire, and has always struggled to keep its head above water. The church, only 51 feet (15.5 metres) long, has Norman origins but was much rebuilt and patched up over the centuries despite the tiny, declining population, and sits on a hummock in the grounds of a manor house, looking like a garden ornament. The fifteenth-century font has some swank about it and must be one of the half dozen best in the county. There are two tiers of decoration; at the top are eight panels of cusped geometrical shapes, all different. My favourite consists of four tiddly tadpole mouchettes swimming around a central quatrefoil. It looks as if the mason miscalculated and couldn't quite fit in the one on the bottom right, and had to squeeze it in vertically rather than horizontally.

The stoup in the porch also dates from the fifteenth century. Stoups are situated by an entrance and are intended to hold holy water; most medieval examples were ejected from English churches after the Reformation. Caldecote's, although much decayed, is I think uniquely large and elaborate. The stoup itself stands on a base decorated with simple quatrefoils, but the crocketed and finialed canopy is an extraordinary extravagance; it even has rudimentary vaulting (looking in its present state a bit like a squashed spider). Why did such flamboyance appear in such an out of the way place? We'll never know.

Above left and above right: Caldecote.

16. CLOTHALL, ST MARY

If this isn't the single most loveable artefact in the whole of Hertfordshire, I'd like to know what is. In the east window there are seventy birds flocking (though some of them are duplicates; one type appears no fewer than eleven times, sometimes reversed), cocksure and confident, perching and roosting on and hopping across the glass, an utterly beguiling translucent aviary, a dawn chorus set singing with every sunrise. Some of them preen their feathers fastidiously; many have one leg daintily poised as if they're taking a step, posing heraldically or contemplating launching themselves into the air; some have open beaks as if they're trilling their song across the treetops; only a few have their wings spread as if in flight. They're full of life, vigour, humour and fun, and whoever painted them (in the fifteenth century) obviously delighted in closely, even rapturously observing them. Contemplating them now is heart-lifting.

I've asked two twitcher friends for help in identifying them, and their view is that they're so stylised that it's hard to assign most of them to specific species. The artist had essentially only two colours available to him: black (made from copper or iron filings), used for the outlines (sometimes with stencils) and some details, and yellow (from silver sulphide), used for colouring in the outlines. The yellow can range from a greenish tinge to something like ochre, but there are no reds or blues.

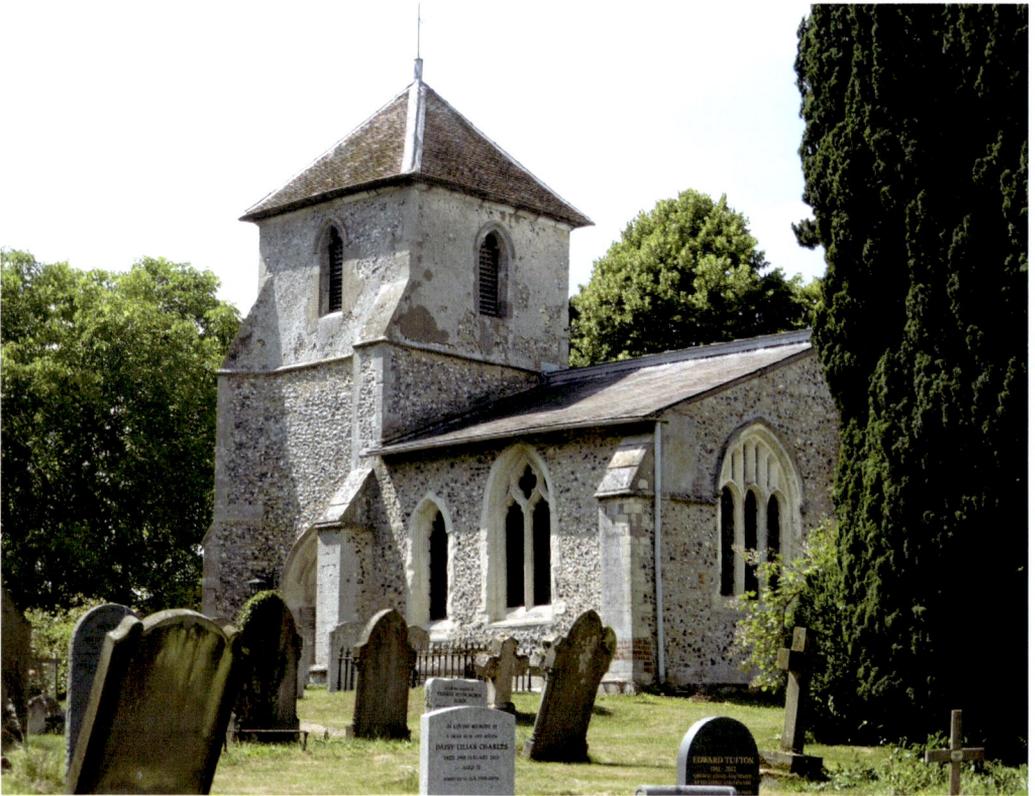

Above and opposite above: Clothall.

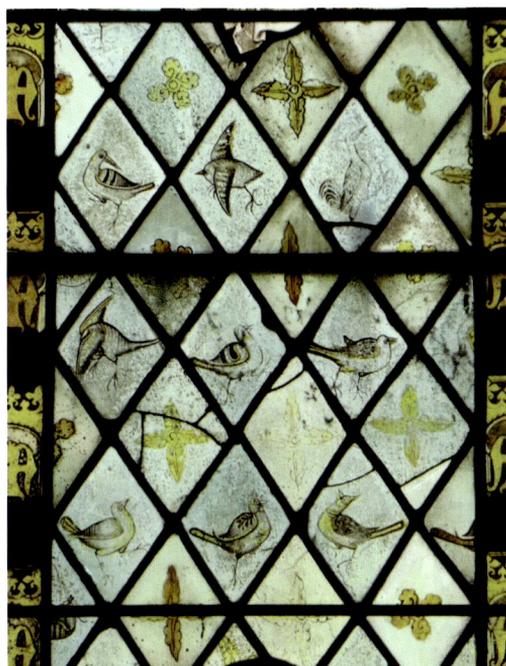

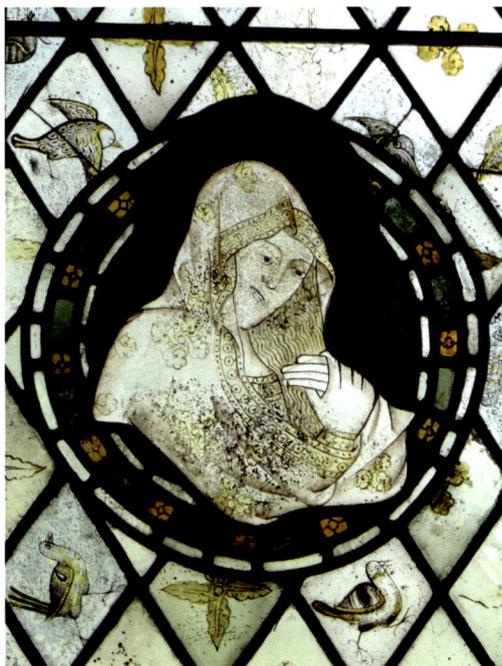

There are also six portraits of Jesus, Mary and the Evangelists, from the late fourteenth century, though they're much restored; Mary perhaps contains the most original material. She is probably not the Virgin but Mary Magdalene, and originally made for the local leper hospital founded in the thirteenth century, which was dedicated to her. This would explain the curiously lopsided nature of her face; a doctor tells me that it looks like a hemiplegia of the left side of her body (her hand may be withered too). Mary Magdalene was frequently associated with people marginalised by society, including lepers and others suffering from disfigurement. The prominence given to her hair (with which, apocryphally, she dried Christ's feet) also supports this attribution.

There are five medium-sized brasses in front of the altar, none of particular note in their own right, but instructive as a sequence from 1404 to 1602 (that is, from late medieval to early modern). The early ones (and aesthetically the best) are very linear, two dimensional and 'clean' (with inscriptions in Latin in Gothic script). There's a gradual transition to the later ones which attempt to portray a third dimension by means of much fussy shading (and are written in English in Roman script).

17. FLAMSTEAD, ST LEONARD

Like many other churches, Flamstead, externally Perp'n'flint, has Norman origins; the flattened round twelfth-century chancel arch is now partially filled with a smaller pointed one from a century or so later. The six bays of the nave arcade, including (probably recut) varied and lively stiff-leaf capitals, are from the same period. There's much to see, including medieval wall paintings, much the biggest collection in a parish church in the county, but, alas, so faded and fragmentary that

they're more of antiquarian than aesthetic interest. The most complete and easily appreciated are the Doom over the chancel arch, with Christ seated in majesty on a rainbow, with an angel brandishing a vicious-looking whip (presumably a reference to the Flagellation), and, bottom right, a Hell Mouth; a Crucifixion in the north aisle, and, over the south arcade, the Three Living and the Three Dead, in which three noblemen out hunting meet the horrifying sight of three walking corpses. The chancel screen is fifteenth century; look for the amusing jesters' heads.

The most notable and original artefact is the Saunders monument (*c.* 1690), usually attributed to William Stanton. Its basic form is standard enough, with an altar-like shelf, elongated winged putti, Ionic columns and the usual heraldic achievement and swags. But what makes this monument special are the six-figure sculptures for which the architecture forms a theatrical backdrop. The inscription names six children, all but one of whom died young; the late five kneel on the 'altar', ranging in age from about one to five (though no dates of birth or death are given). The child on the left (the youngest) is the only one who looks at the viewer. He twists his head around over his right shoulder with lips parted, and an expression conveying – what? Sorrow at his untimely death? Incomprehension at his fate? Reproachfulness at the unjust brevity of his life? By meeting our gaze so fixedly he urges us to join him in railing against the iniquity of oblivion. (I can't help mentioning that he reminds me of a pudgy Napoleon.) The other four

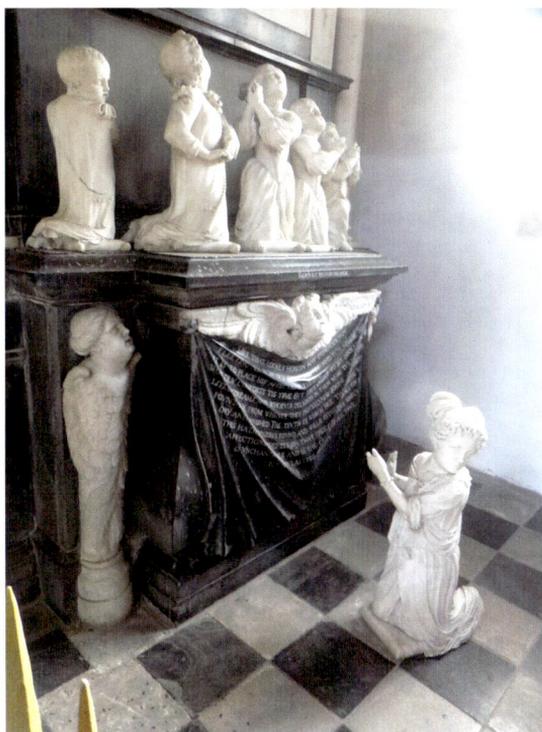

Opposite, right and below:
Flamstead.

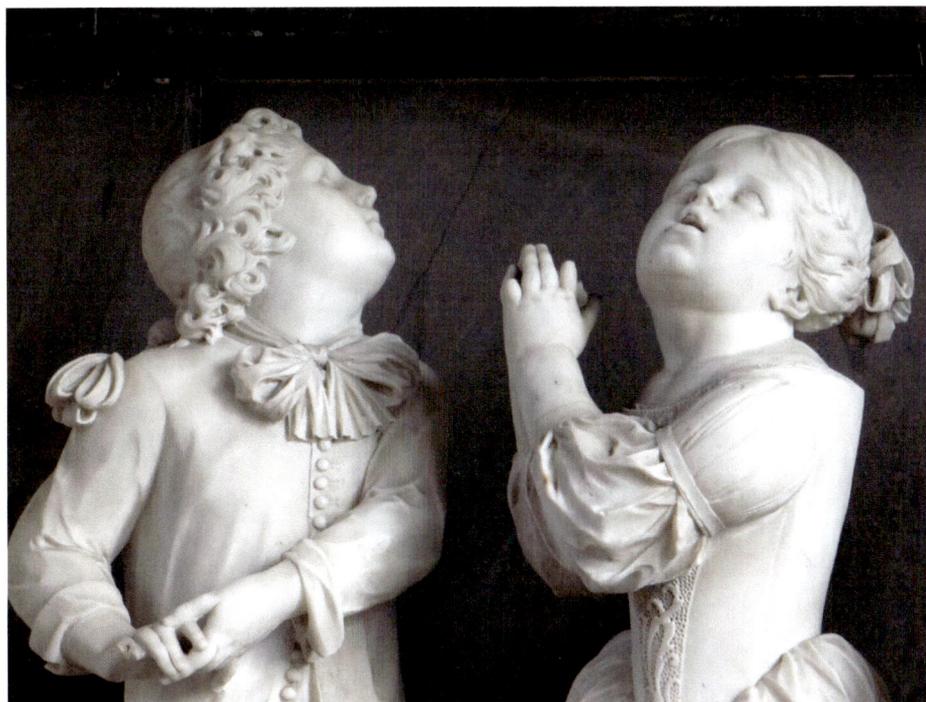

children all look up; they have their hands raised in prayer except the second from the left, who holds them at his side, or could even be wringing them. They all kneel on both knees, except one who kneels on just one. These little differences help to animate the otherwise potentially static array; compare them to the clone-like children on earlier tombs.

They're dressed in adults' clothes, while the one child who was alive in 1690, Anne (1670–1719), wears her burial shroud to remind her and us of the fleetingness of life. Her statue stands on the ground apart from the monument proper, a highly unusual arrangement; she turns her head to make eye contact with us and points towards her late brothers and sisters (all but one of whom she almost certainly never knew), a deeply affecting gesture. I'm in two minds about the expression on her face; is it brilliantly understated or too neutral? The overall effect is also diminished by the figures, especially that of Anne, being too small. Nevertheless, it's a powerfully moving piece of baroque sculpture. (My unscholarly guess is that the monument may have been made on the occasion of Anne's first marriage in 1688. I'm glad to report that her parents lived long enough to see their first grandchildren born.)

Crudely carved into the nave piers are some inscriptions, such as one to 'our NeighboreFrind olde iohn Grigge', who died in 1598. This is so much humbler and more intimate than the Saunders monument, but it's just as, perhaps even more, poignant.

18. GREAT HORMEAD, ST NICHOLAS

For me the chief attraction of Great Hormead is its corbels. It's externally mostly much-restored Perp'n'flint, but step inside and look up slightly to your right. A curious cartoony cat-human hybrid creature has been smirking down into the south aisle for about 700 years, since the early fourteenth century. How should we describe its expression? I can't decide. Is it cheerful? The smile looks too fixed, more like a grimace. Gleeful? Possibly, though perhaps with a hint of malice. Or is there even something a little sinister about it? I admit I find it a bit unnerving. There are seven more corbels in the aisle, including a mouth-puller and a goofily grinning lopsided personality. He seems manic, and could well be the love child of Ernie from *Sesame Street* and a demented smiley emoji.

In the nave are six more corbels, from the fifteenth century, though they lost their structural purpose when the roof was rebuilt in the 1870s and they're now marooned in blank walls. Those on the north are the most intriguing. There are two handsome male heads, one of whom has slanted eyes, bouffant hair and a Delphic smile (what does he know that he's not telling?), and an older ugly man, with pug nose, very pronounced lips, furrowed brow and attempt at a youthful hairstyle, a wonderfully powerful piece of character carving.

Back outside, the clerestory has two grotesque rainwater monster-animal-human heads on each side. Do they date from the building of the clerestory sometime in the fifteenth century? Or are they Victorian? They're not very weathered, though they are prettily lichened. However old they are, they're great. I especially like the shaggy one, who looks cutely strokeable, and the one who seems to be doing his best to appear frightening but ends up looking like a dog eagerly waiting for his master to throw him a stick.

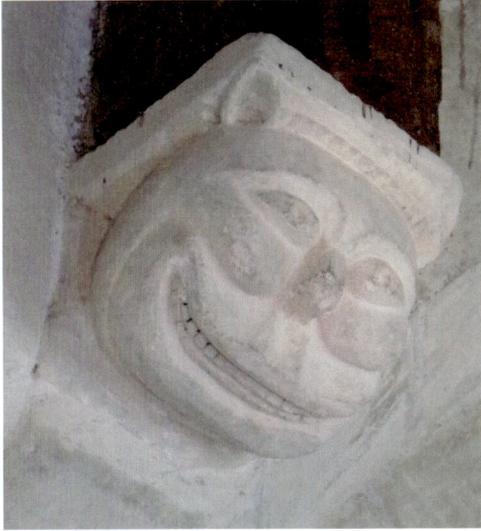

Above and below: Great Hormead.

19. HATFIELD, ST ETHELDREDA

A huge church by the standards of the county, aisleless but with north and south chapels to the chancel, and transepts which, unusually, have west chapels, and externally apparently mostly Dec'n'flint, which at least makes a change from the usual Perpendicular. In fact this appearance is deceptive and dates from only 1871–72. Decorated is a bizarre choice as there's nothing in the church from the fourteenth century. The chancel and transepts are from the thirteenth, and the tower and south chapel the fifteenth.

It's the post-medieval contributions that most catch the eye. There are several worthwhile monuments, for example, those to Dame Agnes Sanders (d. 1588) and

her daughter Elizabeth (d. 1612), with two life-size stiff doll-like figures, and to John Heaviside (d. 1787), a surgeon, by Thomas Banks. This features two women; one holds an inverted torch (a symbol of death), and the other a rod of Asclepius (a staff around which is entwined a serpent, a symbol of healing in reference to Heaviside's profession). The woman on the left looks as if she's about to challenge the other to an arm-wrestling contest.

There's plenty of good Victorian stained glass on show too. Burne-Jones's 1894 window in the south transept gets most of the accolades, and not without

Above and opposite: Hatfield.

justice. The demure figure of St Margaret, huge feather in hand, dressed in white robes with pinkish highlights over an ankle-length sky-blue dress, is particularly fetching. She is casually trampling a burgundy dragon. But let's not overlook the high quality of several by Clayton & Bell, for example, the Ascension in the east window (1872), which shows the firm's skill in unfussily arranging numerous figures and balancing colours, all set against highly ritualistic backgrounds. The

twentieth century contributed a window by Christopher Whall (1920) with three differently coloured gorgeously winged angels, just on the right side of sentimental.

The Salisbury chapel was built in 1618 (it has Tuscan columns and round classical arches, though the windows are purely Perpendicular) to house the tomb of Robert Cecil, 1st Earl of Salisbury (d. 1612), under King James the most powerful politician in the country, and the builder of Hatfield House. The chapel is lavishly adorned with wrought ironwork and high Victorian Italian-style murals, marble and mosaics, but they can't hold a candle to the Cecil monument itself, which is one of the noblest works of its date not only in the county but the country. It's by Maximilian Colt, the King's Master Carver, and cost £460 (about £93,000 today).

Cecil's effigy, dressed in all his finery, is overshadowed by four kneeling women, representing the Cardinal Virtues, who support the heavy black marble slab on which it lies, shouldering their burden effortlessly and uncomplainingly. They are a stern Justice, with sword and axe; a doleful Fortitude, wearing figure-hugging armour and carrying a broken column; Temperance, with downcast eyes and wearing armour which, impractically, leaves her breasts exposed, and who carries two water pitchers; and bare-breasted Truth, studying herself intently in a mirror, who has a serpent with winged ears wrapped around her arm. Beneath the slab lies a horrifying skeleton as a *memento mori*, a revival of the motif from late medieval cadaver monuments.

Hatfield.

It's all so compelling that it's easy to not pay attention to where we're treading and trip over two more unusual and fascinating monuments, both embedded in the floor: a smaller than life-size thirteenth-century faceless knight, with a shield acting as a kind of blanket, and the shrouded effigy of William Curll (d. 1617), who twists himself animatedly as if caught in uneasy sleep.

20. HEMEL HEMPSTEAD, ST MARY

A major, complete, Norman cruciform church, built *c.* 1150–90. The spire is later, many of the windows were updated in the fifteenth century, and of course there have been restorations, but otherwise the structure is mostly untouched. It is mightily impressive, its presence only slightly diminished by its position on sloping ground below the High Street.

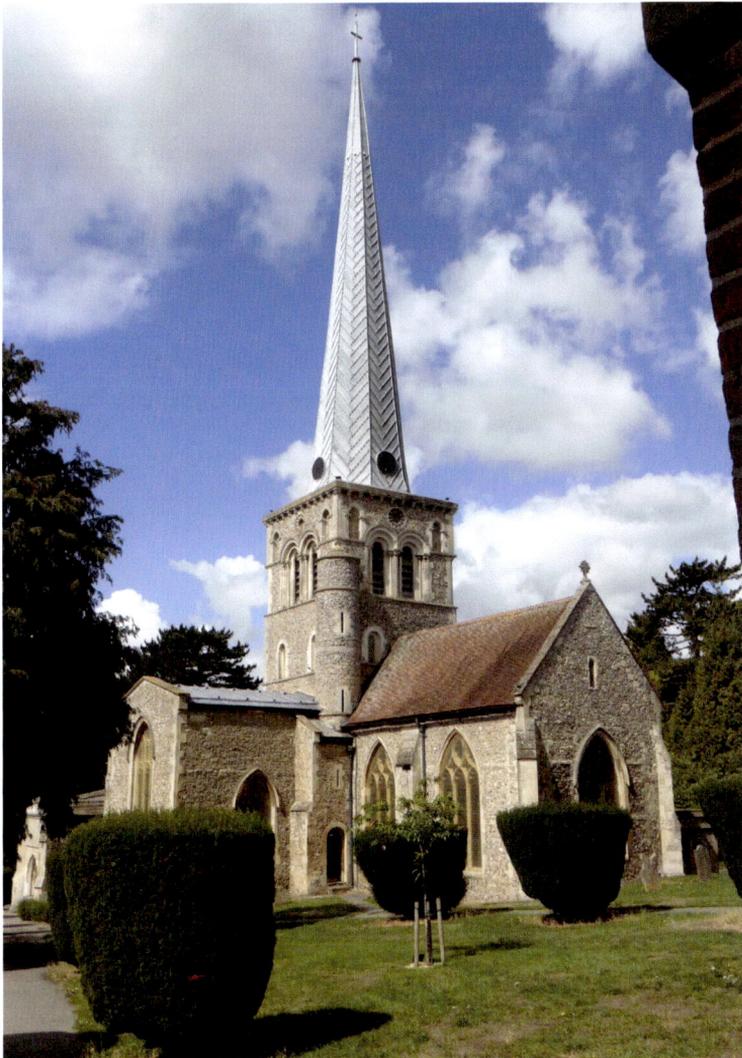

Hemel Hempstead.

The west doorway exhibits probably the most elaborate Norman carving in the county, although knocked around and covered in paint, with three orders of billet moulding and lozenges, and some small human figures lurking on the capitals. The nave is of six bays with typical chubby piers, plenty of chevron and scalloped capitals, no two of which are quite alike. The chancel is – a rarity – vaulted. Sadly, unlike many major Norman churches there isn't much figural carving, but a close look at the crossing will reveal several foliate heads ('green men') and what looks as if it could be a horse but is probably a sheep skulking among the serpentine plant stems and stylised leaves.

In a county not known for its spires (Stevenage seems to be the only other medieval one) it's a surprise to find that Hemel Hempstead's is, together with the tower, at nearly 200 feet (61 metres), arguably the second tallest of timber and lead in the whole country. (It's hard to find definitive measurements, but the famous twisted spire of Chesterfield, Derbyshire, is probably the tallest.) It's perhaps fourteenth century, and obeys the cardinal rule of spires in that it's about the same height as the tower on which it stands, which creates a very satisfying sense of balance. However, the junction between the top of the tower and the bottom of the spire is unadorned by pinnacles, parapet or any other feature, and the four corners look empty and stark.

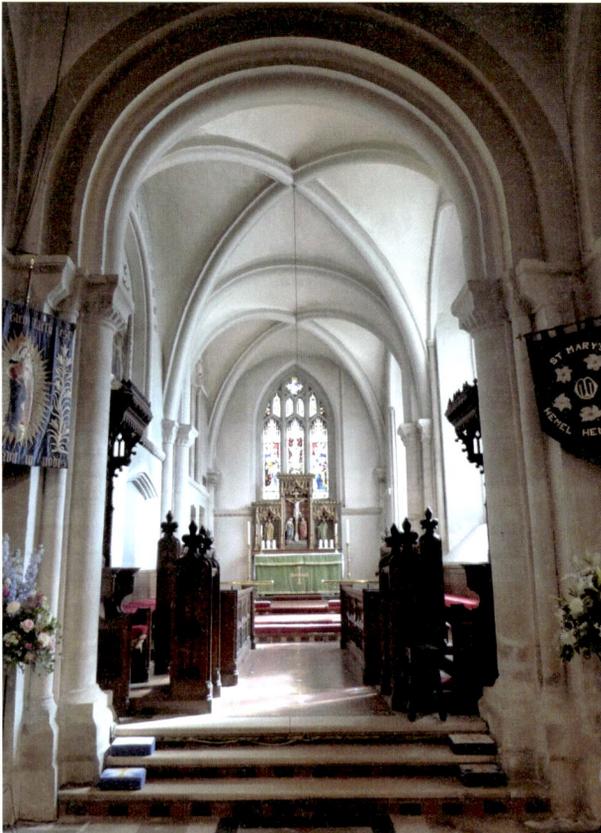

Hemel Hempstead.

21. HIGH WYCH, ST JAMES

High Wych church, built in 1860–61, is one of the most individual in Hertfordshire. The nave and south aisle, under one big, broad, steep roof, are conventional enough, with Early English-style lancet windows mostly in pairs. There are bands of red brick to alleviate the expanses of knapped flint. The east end, however, is a different matter, with not one apse but two, one nestling into the other like a child being cuddled by their mother. The larger one is of course the chancel; the smaller one, on the south, you'd expect to be a chapel, but is actually the vestry. The view from the south-east is very pleasing. (In addition to the two eastern apses the south porch has a strange low demi-apse on its west side.)

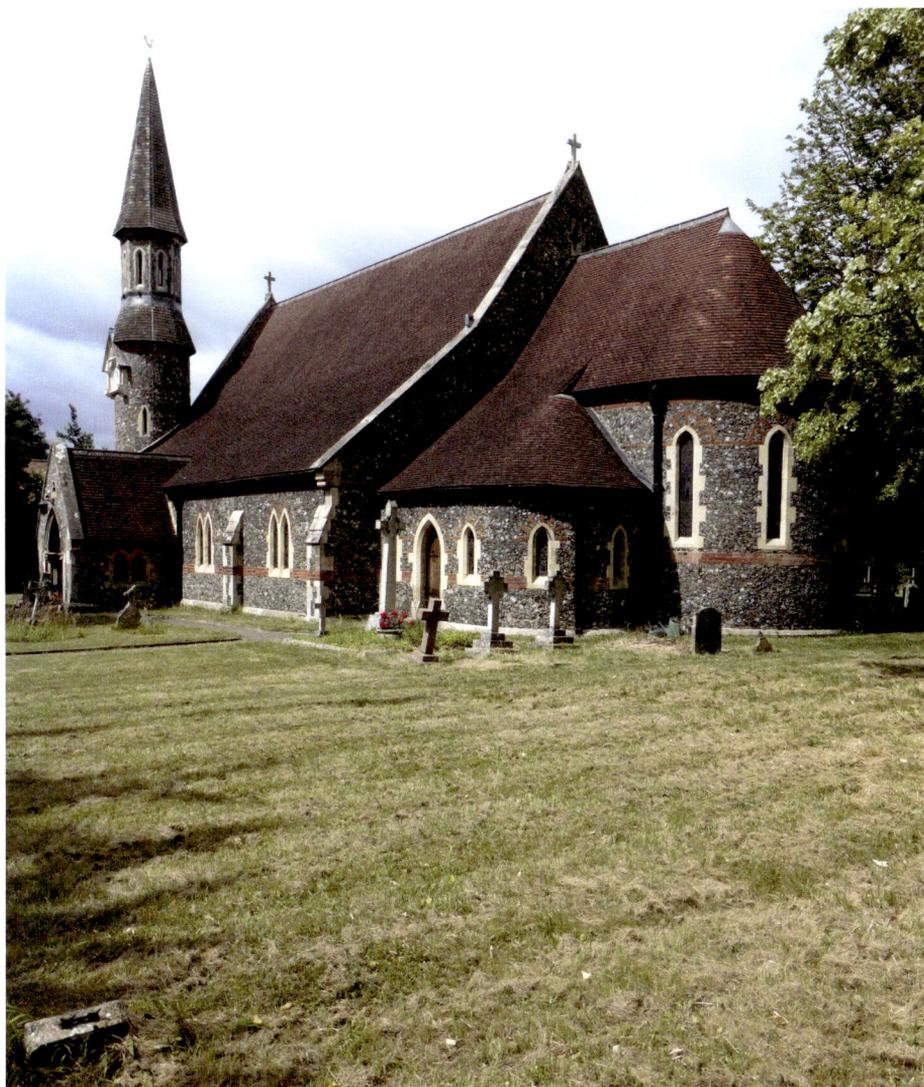

High Wych.

But the most arresting external feature is the unusually slender round steeple, which protrudes from the west wall of the nave. It starts as circular; when it nears the height of the nave roof it becomes a truncated cone, on which sits the octagonal belfry, and the whole composition is topped by a shingled spire. It's hard not to compare it to a two-stage rocket or missile. It's almost elegant, but on its south is a clock (not part of the original plan) under a large gable, which strikes me as gawky and an unfortunate visual distraction.

The interior is dramatic, particularly the roof with its numerous trusses, but quite dim. The south arcade has big square capitals carved with not very attractive leaf forms, atop spindly columns. The walls are all of white brick with a band of red (corresponding to that visible outside) and alternating voussoirs of red and white in all the arches, creating many very engaging patterns.

The main attraction is without doubt the chancel, retaining all its original decoration in an unrestored state and mostly well preserved. The polychromatic brickwork (some of the bricks are shaped) is more extensive than in the nave, and every foot of the walls and vaulted roof is covered in painted and/or stencilled decoration, abstract patterns mixing harmoniously with symbolism and texts. It's an exhilarating, almost overwhelming, sight.

The architect was G. E. Pritchett of Bishop's Stortford, and the church cost £2,000 (about £192,000 today). It has divided opinion; in the Hertfordshire volume (1953) of his magisterial *Buildings of England* series Nikolaus Pevsner called it 'perversely ugly' and 'an eminently typical example of High Victorian design at its most revolting'. Sorry, but got to disagree with you there, Sir Nik.

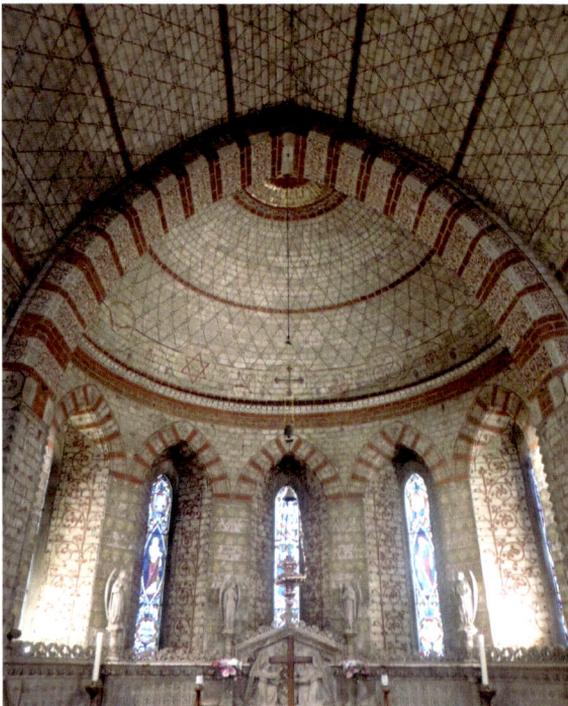

High Wych.

22. KNEBWORTH, ST MARTIN

Sir Edwin Lutyens is best known for his country houses and the Cenotaph in Whitehall, but he also designed half a dozen churches. Built in 1914–15, St Martin externally presents a peculiar shape to the world. It's built of brick. The ground plan is almost rectangular; there are transepts but they are subsumed into the aisles, which are wider than them. Seen from some angles, with its preternaturally

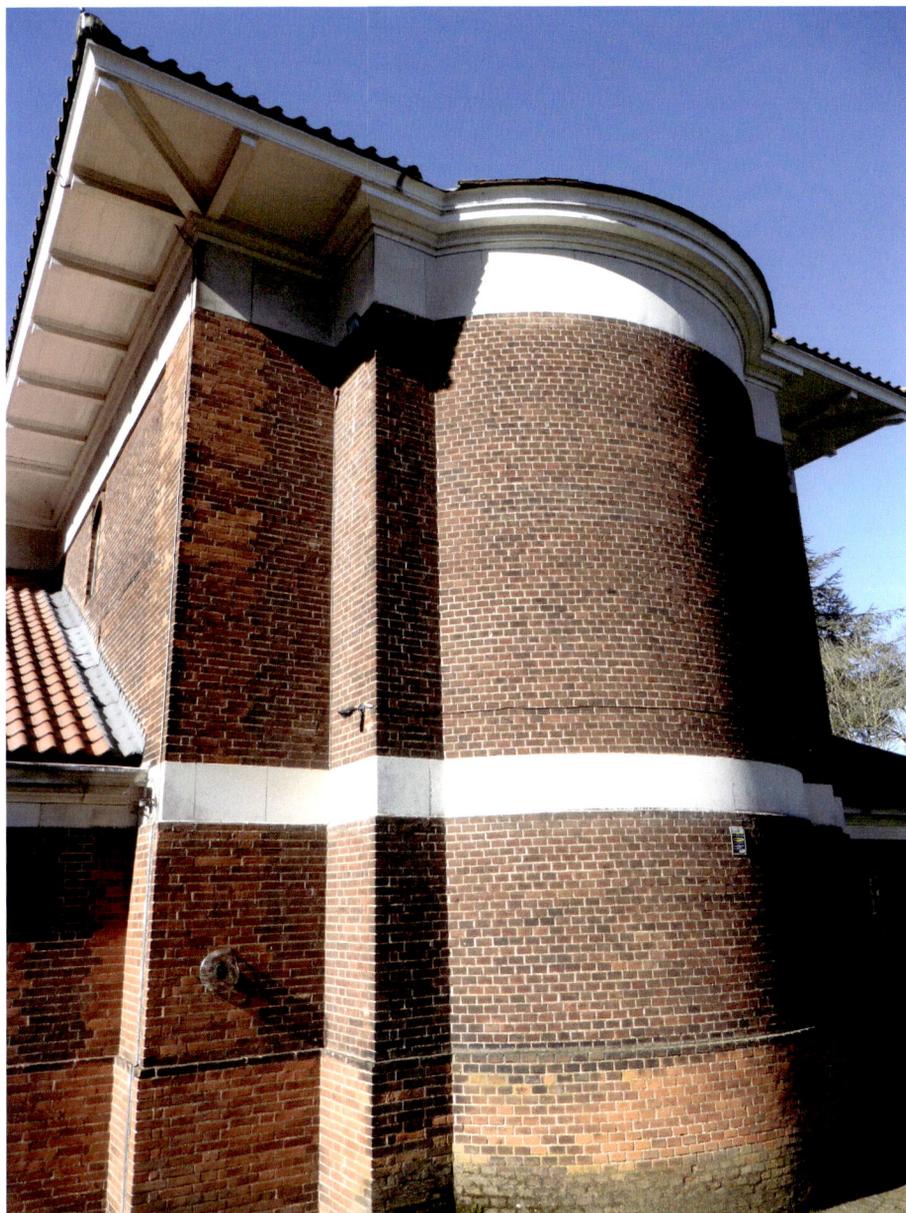

Knebworth, St Martin.

oversized eaves it looks like a sprawling, truncated pagoda. There are some round windows, and some of the shapes created by the apsidal east end (which reminds me of that of Ayot St Lawrence) are intriguing, but I'd be hard pushed to describe the whole effect as beautiful.

The interior is another matter. The walls are pure plain white (except for the pale blue shallow apse), and there's what seems like a forest of white Portland stone Tuscan columns. All but two of them are what we might call normal size, and are grouped in twos and threes with the plainest possible little classical arches between them. The two exceptions, which support the flat roof of the transepts, are positively Brobdingnagian, well over twice as tall as the others, of plastered brick. This results in thrillingly ever-changing vistas as you walk around; with each step a new angle is revealed, and every now and again the two titanic columns come into view, somehow giving you an inappropriately little shock each time. Lutyens' manipulation of space from a few very simple elements is masterful.

The nave was never finished to Lutyens' plans, and was not completed until 1963–64. He intended it to have been much longer than as built, and the west end

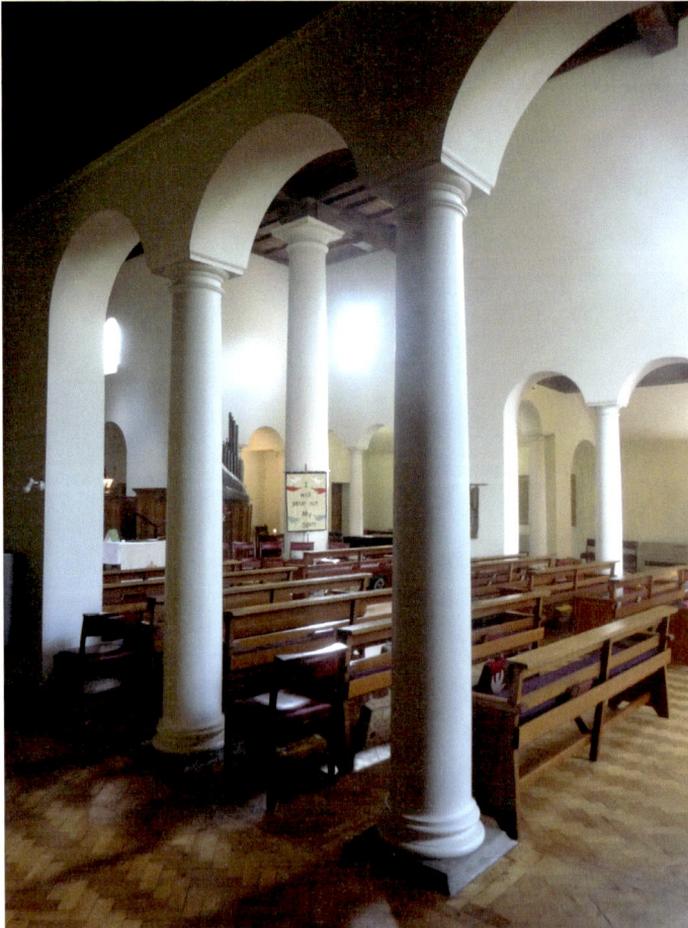

Knebworth,
St Martin.

would have culminated in a narthex with a large central doorway surrounded by windows. Terribly grand and over-ambitious for what was after all just a village church, the whole thing was verging on megalomaniacal (like his aborted plans for Liverpool's Roman Catholic Cathedral), and it's a wonder that anything got built at all.

23. KNEBWORTH, ST MARY AND ST THOMAS

Situated next to the phantasmagoria of turrets, ogee cupolas, gargoyles, battlements, pinnacles and ranks of heraldic beasts that is Knebworth House, home of the Lytton family, the church is a relatively quiet affair. Its origins are Norman, most obviously seen in the plain chancel arch, but has been much rebuilt (the chancel for example is mostly early Victorian). The tower with its taller stair turret and Herts spike is early fifteenth century.

There's much of interest inside, however, including four Flemish carved panels (1567) incorporated into the later pulpit, showing scenes in the life of Christ from the Annunciation to the Circumcision, via an Adoration with particularly grim-faced Magi, several hatchments, a Queen Anne coat of arms, and Christopher Whall Arts and Crafts stained glass commemorating a soldier who died in the First World War. In the first panel he's an idealised and anachronistic knight in

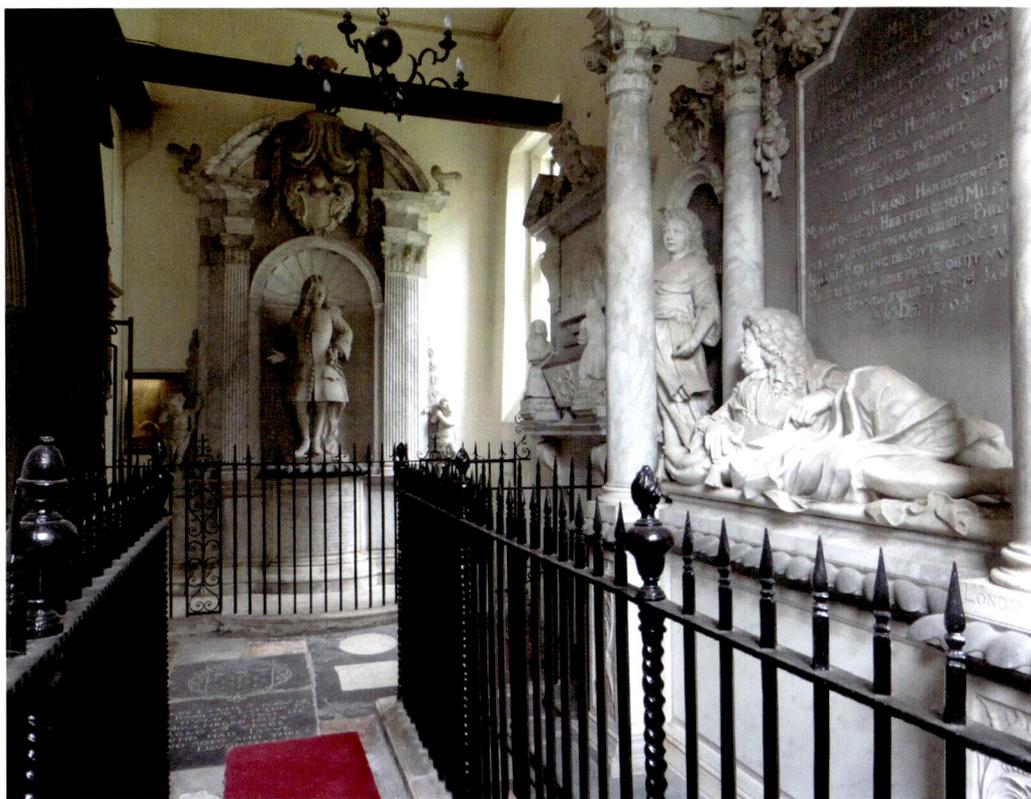

Knebworth, St Mary and St Thomas.

gleaming armour, whereas in the second he hangs his head despondently and has dropped his sword and shield, and is wearily unbuckling his now battle-scarred breastplate. The window, unlike many such memorials, makes at least a token gesture to the reality of warfare.

It's the Lytton Chapel that makes the church worth going out of your way to see. It was originally built in the mid-fifteenth century but was remodelled *c.* 1705. The current formidable wrought-iron gate, by Sir Edwin Lutyens, replaced the original in 1935; the latter, much more playful, is now under the tower. There are three large standing monuments (as well as two smaller mural ones) crammed into much too small a space, each trying to elbow the others out of the way to get our attention. On the west wall is the stylish Lytton Lytton (d. 1710, aged twenty-one), who stands between two weeping putti, with a Mona Lisa semi-smile and a frothy soapsud wig. Like his relations he wears clumsy-looking square-toed buckled shoes. His left arm akimbo, his hand presses a sheet to his side, which tumbles to the ground – a shroud, perhaps. The railings protecting his monument are particularly exquisite.

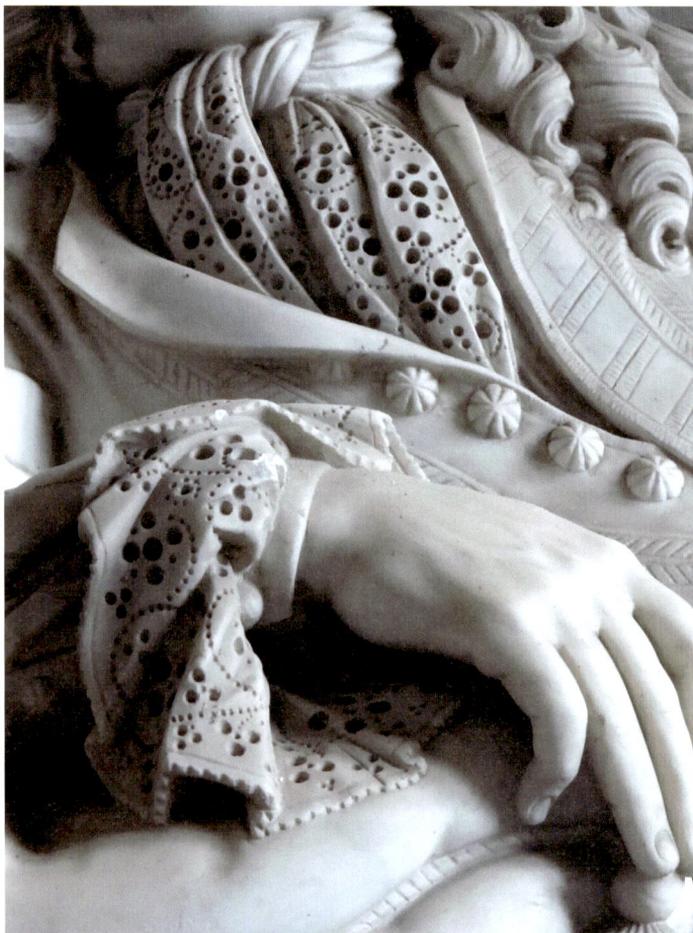

Knebworth, St Mary and St Thomas.

No smiles from his great uncle, Sir William Lytton (d. 1705), portly, double-chinned, semi-reclining, spreading himself almost voluptuously, turning his head awkwardly round to his right. His clothing is depicted fastidiously, especially his lace cravat and cuffs. He looks enormously self-satisfied. The architectural setting is very grand and incorporates two near-life-sized allegorical figures (symbolising I'm not sure what). The whole thing is signed with what looks like impudent prominence by Edward Stanton (the son of William Stanton; see Flamstead). Facing him, uncomfortably closely, is his nephew (and Lytton Lytton's father) Sir George Strode (d. 1707), even more stern of countenance, his right hand pointing to the east (possibly a reference to the Last Judgement).

In the chancel is a remarkable monument to Judith, Lady Strode (née Lytton) (d. 1662). Her austere white marble bust is of classical purity, but it's set within and contrasted with a simple yet eventful and original black marble background with attached columns at the side that curve and bulge like vases. It's attributed to Thomas Burman, who made his maid-servant pregnant and blamed it on his apprentice, John Bushnell, and then tricked him into marrying her. Bushnell responded by fleeing to Rome, taking £15 (about £2,500 today) of his master's money with him, and, an even more stinging revenge, became the better sculptor of the two.

24. LITTLE GADDESDEN, ST PETER AND ST PAUL

The heart of the church is fifteenth century, but the lithely vaulted south chancel chapel, dating from 1819, and the south aisle and porch, from 1830, are early Gothic Revival. They're by Sir Jeffry Wyatville, whose uncle James Wyatt was responsible for the nearby vast Ashridge House (Sir Jeffry helped to complete the project after his uncle's death).

The nave is crammed with mostly mediocre monuments. My favourite objects here are the small ceramic Art Nouveau-ish angels on the late Victorian pulpit, which are just on the right side of twee. They're by Mary Watts (1849–1938) (whose husband was the painter G. F. Watts), a significant craftswoman in her own right (she was the designer of the extraordinary Watts Memorial Chapel in Compton, Surrey). The chancel is sumptuously decorated; the outstanding features are the two hanging light fittings (presumably originally for oil lamps). They must be, like the pulpit, late nineteenth century. The little gilded wings are a delight.

The best monuments are in Wyatville's south chancel (Bridgewater) chapel. The chief attraction of the one to Elizabeth, Viscountess Brackley (d. 1669), is the deliciously curly 'handwriting' on marble fictive drapery. Note for example the multiple swirls at the top of the capital E in 'Earle' in the second line, and that several of the capital Os are so elaborate that you virtually get two letters for the price of one. The putto head at the bottom looks even more gormless than they often do.

That to Francis Henry Egerton, 8th (and last) Earl of Bridgewater (d. 1829), is by Sir Richard Westmacott. It depicts a pensive seated woman leaning on the head of an elephant (it's either unusually small or she's unusually big). Behind her are a stork-like bird and a tree bearing fruit; at her feet swims a fish or dolphin. She holds a book entitled 'WORKS OF THE CREATION'. The 8th Earl

Little Gaddesden.

was an ordained priest (though he employed curates to do his parochial work for him) and a theologian who argued that the natural world was proof of God's existence. He was also a noted eccentric. His dogs were treated as nearly as possible as if they were people; they travelled on cushions in luxurious carriages, and were fed with linen napkins around their necks, seated at a table. He also, less eccentrically, left a highly important collection of historical manuscripts to the British Museum.

Which brings us to his cousin John Egerton, 7th Earl of Bridgewater (1753–1823), who took over where the 3rd Duke left off and built Ashridge House, and was a soldier and politician. His monument is also by Westmacott, but while the later monument is clumsy to the point of being somewhat comical,

Little Gaddesden.

this one is graceful and deeply affecting. It's an altarpiece in the form of a tondo, and focuses on a couple and their child. It was originally exhibited under the title 'Afflicted Peasants', but there are obvious parallels with the Holy Family. The mother tenderly snuggles her sleeping child while his hand grasps her nipple. Her bare right foot, its sole exposed, appears very touchingly vulnerable. Her husband wears a working-man's smock, and behind them is an older man, maybe the father of one of the couple, holding a staff or perhaps a tool such as a hoe. At the bottom right is a dog, I think the only weak point in the composition. The younger man rests his hand upon the tools of his trade, a spade and a scythe, together with harvested ears of corn. They almost 'break the frame' by spilling out of the sculpture towards the viewer, inviting us to imaginatively step into the scene.

25. LITTLE HORMEAD, ST MARY (CHURCHES CONSERVATION TRUST)

A small but charismatic country church with only one outstanding feature (though the font is good too) – but what a feature. It's of national importance: a door from the first half of the twelfth century with dynamic geometric ironwork. Originally there were also four dragons, but only one survives. Alas, the church has been closed for some years while the door is awaiting

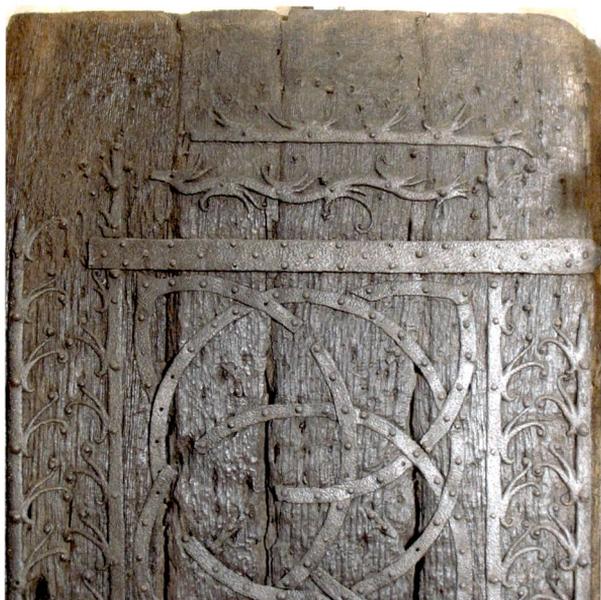

Little Hormead. (Churches
Conservation Trust)

conservation. Let's hope that it can reopen soon. The author's royalties from
this book will go towards its restoration.

26. MEESDEN, ST MARY

Meesden church's first attraction is its secretive sylvan location, unsignposted,
at the end of an avenue of trees and all but invisible from the road, half a mile
from the one-street village. It was substantially rebuilt by the prominent Victorian
architect Sir Arthur Blomfield in 1876–77 (he is responsible, for example, for the
very pretty timber shingled bellcote), but the plain Norman south door reveals its
earlier origins.

The Tudor brick south porch is one of the church's two outstanding features.
It was built *c.* 1530, and no one seems to know why such a large and elaborate
structure was added to what's always been a small, out-of-the-way church. By
rights it should be the gateway to a much grander building. Sadly, it's been brutally
repointed at some time, the cement being slapped on like butter straight from the
fridge. One oddity is that the bricks above the corbel table are noticeably different
from those below, being less flat, darker in colour and more regular in shape;
in other words, they're modern bricks, and the turrets and battlements are
Blomfield's excellent work (a fact unnoticed and unrecorded until now).

The church's star attraction, however, is the pavement of variously shaped
mosaic tiles around the altar, from the earlier fourteenth century. (They were
perhaps made by the same tilers responsible for those, even more extravagant,
in Ely's Prior Crauden's chapel, 40 miles to the north.) They spread out from
the altar, first of all in a fan shape, which is surrounded by a rectangular border,
which in turn is surrounded by a bigger, more complex border. This outer border
consists of nineteen circles, each of which contains a cinquefoil, which in turn are
surrounded by four smaller circles. The colours have worn and faded over the

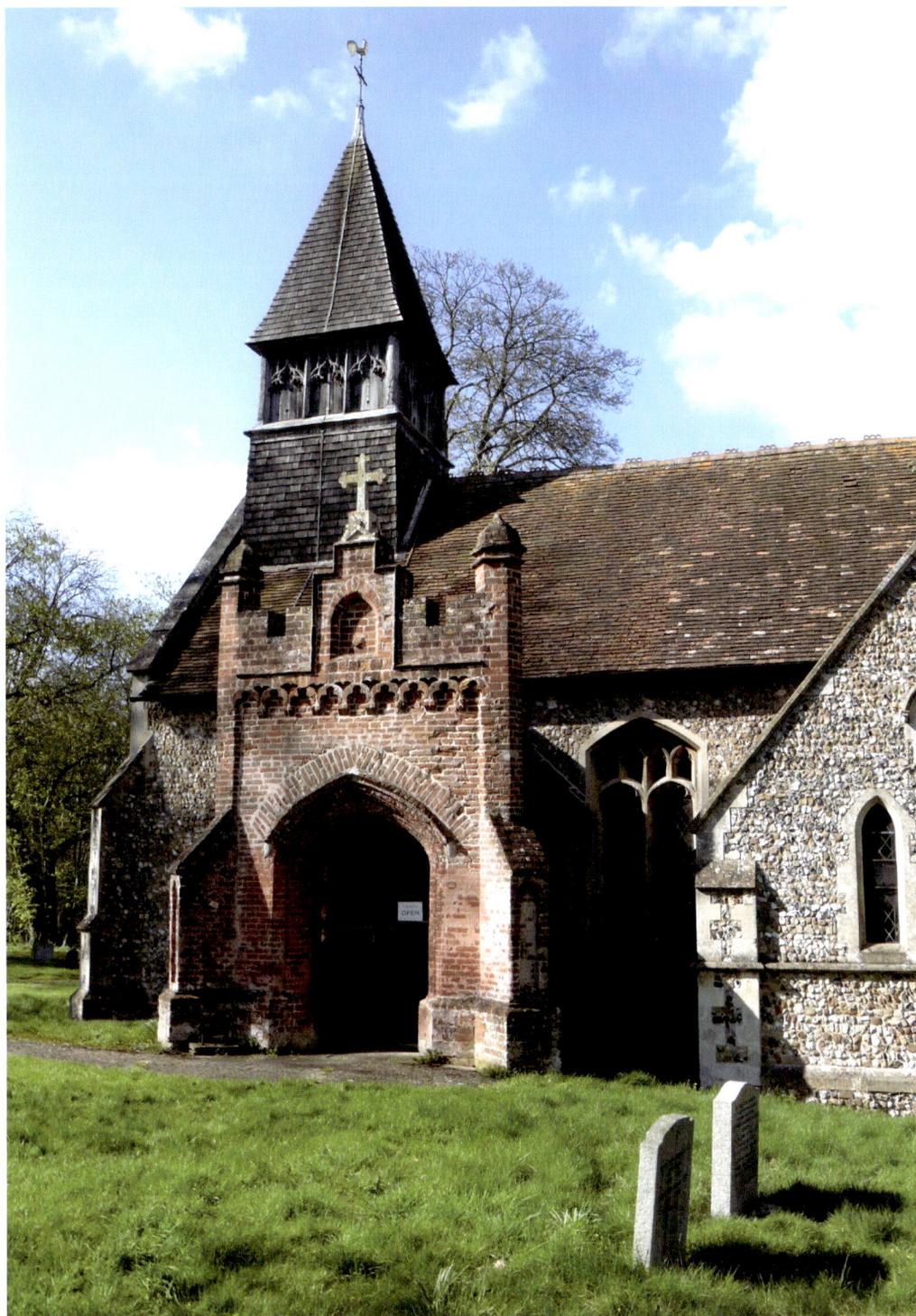

Meesden.

Meesden.

centuries; what remains are mostly dusty yellows, dark greens, various shades of browny-orange and blacks. Many of them have been stamped with little designs: foiled circles, crosses, petal-like shapes and eagles. There are also two coats of arms of the Monchensey family, lords of the manor from the late thirteenth century. In the opaque yet relishable antique jargon of heraldry the design on the shields is known as Barry Vair and Gules (which sounds like a 1950s variety act, perhaps a ventriloquist and his dummy).

The plainly panelled seventeenth-century font has been broken into several pieces and stuck back together, possibly as the result of a short-lived ordinance of 1645, which effectively outlawed fonts in favour of basins. This law was never enforced with any great vigour – thankfully so, otherwise no medieval fonts would survive.

27. Offley, St Mary Magdalene

From outside a curious sight: the original thirteenth-century flint and rubble nave is sandwiched between the faintly Gothic red-brick tower (1800) and the stark, tall, almost windowless Portland stone chancel (1753–77). Inside, it's one of the county's most richly interesting churches.

On the octagonal piers of the nave arcade (*c.* 1230), which lean outwards at an alarming angle, there is a good and varied display of Early English stiff-leaf capitals, some of them wind-blown while others are much more static and formalised. Each of the eight faces of the fourteenth-century font features blank tracery, as if from the top of a window. Some of the tracery is in the curvaceous Decorated style (prevalent *c.* 1290–1350), but some of it is Perpendicular (*c.* 1350–1530), with many straight lines, especially vertical ones. The crockets, finials and rosettes are all carved in high relief so the play of light over them enlivens the surface of this delicious artefact. Next to the font is a monument (1699) probably by Grinling Gibbons, best known for his spectacular – indeed, miraculous – limewood decorations. His stone carving is clumsy in comparison.

Before the Victorian Gothic Revival, when the medieval methods of making stained glass were revived, figurative glass was painted rather than stained. In stained glass the colours are in the glass itself, but painted glass consists of coloured enamels applied to plain white glass (and then fired in a kiln). Two examples can be seen at the east end of the north aisle, and one more (by William Peckitt of York) in the chancel.

We've seen the forbidding chancel from the outside; now let's go in. It's entered through a tall classical chancel arch with a plaster-panelled soffit, and round-headed

Offley.

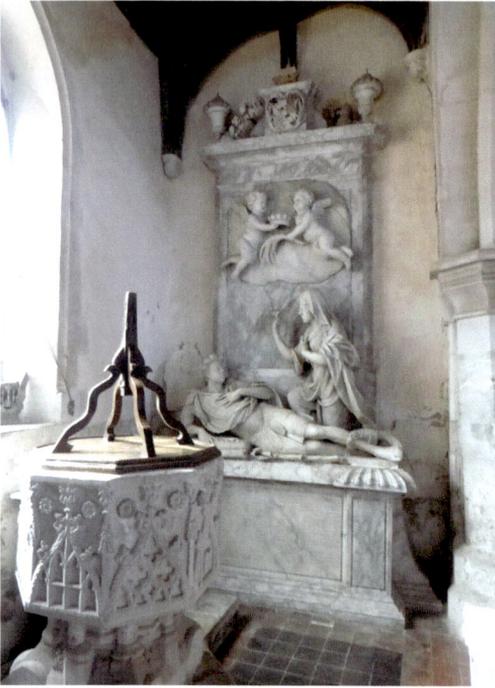

Above left and above right: Offley.

niches containing busts in the jambs on each side. (However, there are some Gothic features, such as the east window with its pointed arch.) Surprisingly, despite the lack of windows visible from the outside, it is light (being lit by a glass lantern), spacious and stately. It is in effect a Georgian mausoleum to the Salusbury family. There are several highly characterful busts and two major monuments. The largest and most imposing is by Joseph Nollekens, who is widely thought of as the best sculptor of his day; it was made in 1777. It commemorates Sir Thomas (d. 1773) and Dame Sarah (who made her will in 1804) Salusbury. Sarah had the chancel altered to accommodate it, and for more than a quarter of a century had what we might think the unnerving experience of seeing this statue of herself every time she went to church. She was his second wife; the exact details are obscure, but there is a tradition that they originally met and became informally engaged many years before their marriage (and presumably before his first marriage), but were then parted. They were eventually reunited beneath an oak tree – a beguiling story whether true or not.

28. Oxhey Chapel (Churches Conservation Trust)
Built by Sir James Altham as an estate chapel in 1612 in an attractive chequerwork of redbrick and knapped flint, with limestone dressings, its history is as chequered as its walls. In the Civil War it was used as a barracks, and it was rescued in 1688, but by the nineteenth century was disused. It was rescued again in 1852, but by the 1960s was in danger of collapse. It's now in the safe hands of the CCT.

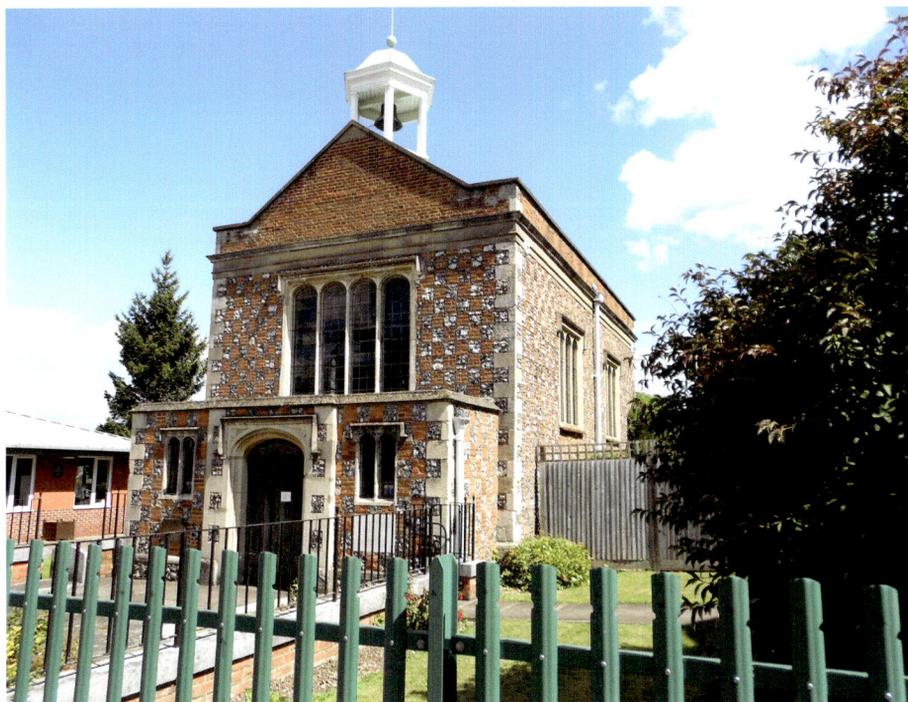

Above and below: Oxhey.

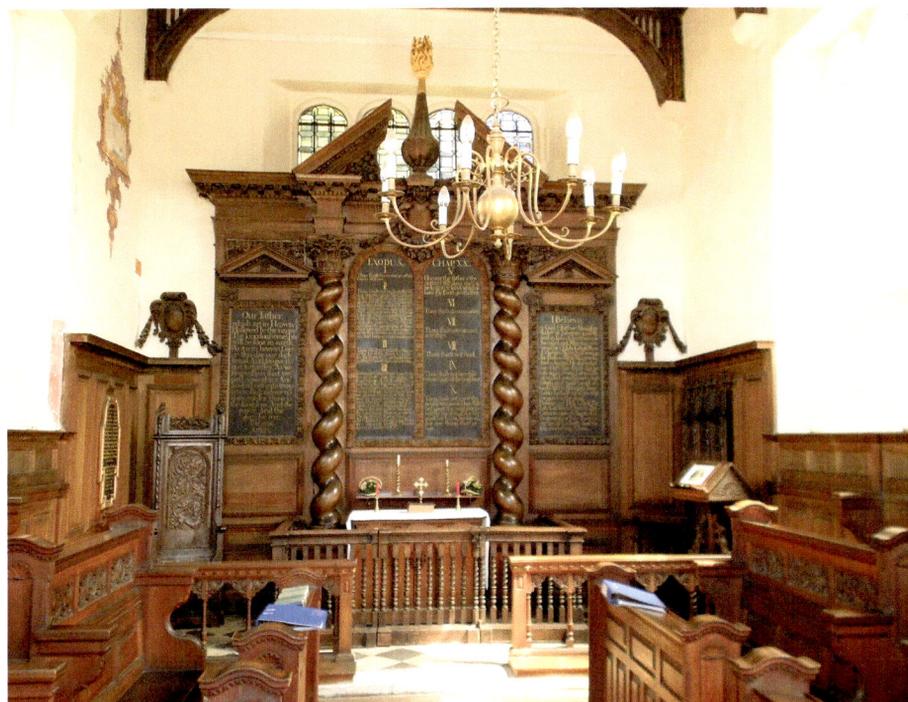

It's another Gothic Survival building (see Buntingford), as the windows (in the style of *c.* 1500) reveal, though internally the only hint of Gothic is a tiny bit of cusped tracery hidden away in the spandrels of the roof beams. The 1688 reredos dominates, being imposingly, almost bombastically, baroque with its broken pediment, abundant fruit carving and twin twisted columns, and puts the Lord's Prayer, Ten Commandments and Creed unignorably front and centre (though perhaps the effect is slightly undercut by a small central grimacing grotesque head). The contemporary oak font is carved with intricate, mannered foliage. The doorcase, with its Corinthian pilasters, is also original, but the pews and return stalls are from an 1897 restoration. They complement the original woodwork perfectly without outshining it.

Altham was one of the two judges who presided over the trial of the so-called Pendle (in Lancashire) witches in the same year as the chapel was built. This is the most infamous witch trial in English history, with the highest death count. Ten people were hanged for witchcraft, all but two of them women. One particularly disturbing aspect of the trial is that one of the chief witnesses for the prosecution, Jennet Device, aged about nine, gave evidence against her own mother, Elizabeth, who was executed. Who would have thought that suburban Oxhey, and its charming chapel, now surrounded by post-war estates, has close links with this deplorable episode?

29. PRESTON, ST MARTIN

The church, built in 1899–1900 by the obscure T. B. Carter, is initially unprepossessing as we approach through the guard of honour provided by the yews. Pebbledash and slate aren't particularly sympathetic materials; the small windows under segmental arches remind me of a light industrial workshop, though the east end is half-heartedly Gothic. The west front, a clipped equilateral triangle with bands of stone, looks forward to the twentieth century.

The east window (1900) is by Christopher Whall, a key figure in the Arts and Crafts movement. It's a Tree of Jesse, showing the ancestry of Christ, with an elderly bearded God the Father (rather than the more usual youthful Jesus) surrounded by seven haloed doves at the top. One poignant panel illustrates the lines 'By the rivers of Babylon, there we sat down, yea, we wept', from Psalm 137. (In Barkway there are substantial fragments of a mid-fourteenth-century Jesse window, and in Widford one by Clayton & Bell (1912), which most unusually features as many women as men, which I like to think was an endorsement of the suffragette movement.)

Best of all are two windows by local artist Peter Caller (based on a sketch by Ruby Masters). One in the nave (2000) depicts St Martin clothing a beggar with the half-cloak he's just cut, watched by people and animals. The bottom of each light is particularly full of detail. On the left vortices of water in which eels and other fish swim swirl around dogs' legs, but clearly we're not supposed to think that the dogs are actually standing in water – it's as if the water is in a different dimension to the figures. There are bands of different colours, and the leading is used to break up the picture into irregular pieces, some quite large, others tiny. The figures on the right represent the holy family, and at the bottom a hare looks up at Martin, and there's some allium – a plant I'm particularly fond of – and

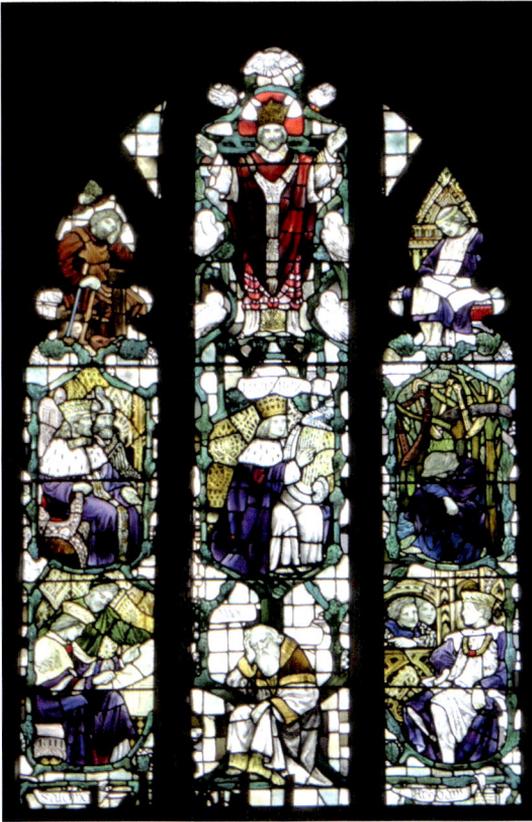

Above left: Preston window by Whall, 1900.

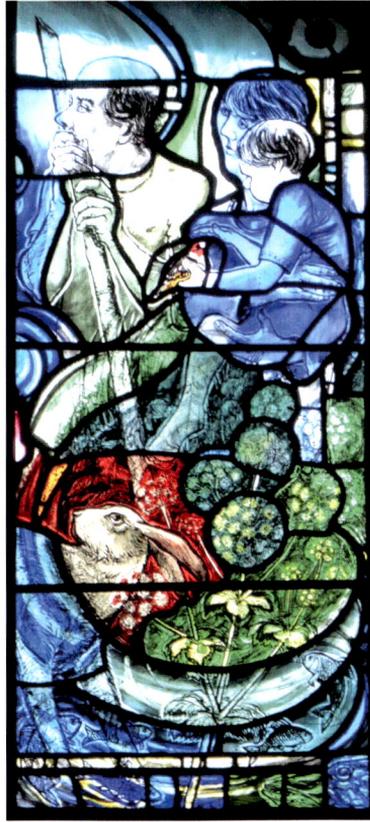

Above right: Preston window by Caller, 2000.

more fish. In the bottom right corner we can glimpse a larger predatory fish with dangerous-looking teeth – a pike, presumably. The cute little fish are likely to be in imminent danger; the window celebrates selflessness, but there's not a lot of that to be found in red in tooth and claw Nature. The whole thing is a moving meditation on loving kindness in a sometimes cruel world.

The other Caller window (2001) is in the anteroom and is a memorial, to an ex-soldier who'd been a prisoner of war in the Far East, in the shape of a wreath. It's not as many-layered as the first, but still stops you in your tracks.

30. St Albans Cathedral

Even today, St Albans' crossing tower (built of salvaged Roman bricks, *c*. 1088) dominates distant views of the town. And even today, the immensely tall piers and arches which support it are awe-inspiring. Visitors who answer their call will not be disappointed.

St Albans was one of the wealthiest and most prestigious abbeys in England, but mismanagement and bad luck meant that the architecture doesn't entirely reflect this

(although the scale is undoubtedly monumental – it's the second longest medieval English cathedral, after Winchester). Abbot John de Cella (1195–1214) seems to have made a hash of the finances and organisation and in 1197 had to suspend work on the nave and sent Hugh de Goldcliff, the mason, packing without pay. What's more, in 1323 (a year after the fall of Ely's central tower) the six easternmost bays of the Norman nave's south arcade collapsed. They were rebuilt in a Gothic

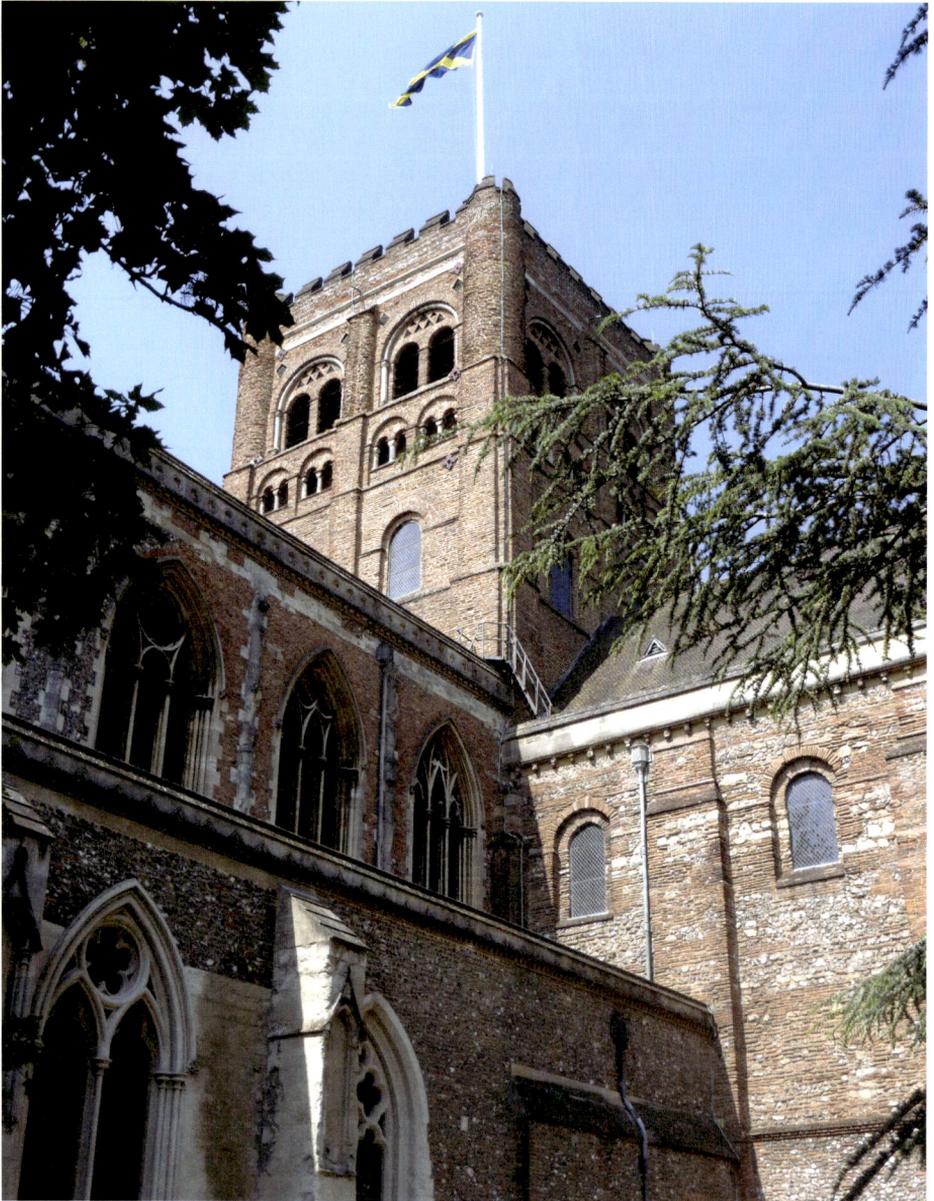

Above and opposite: St Albans Cathedral.

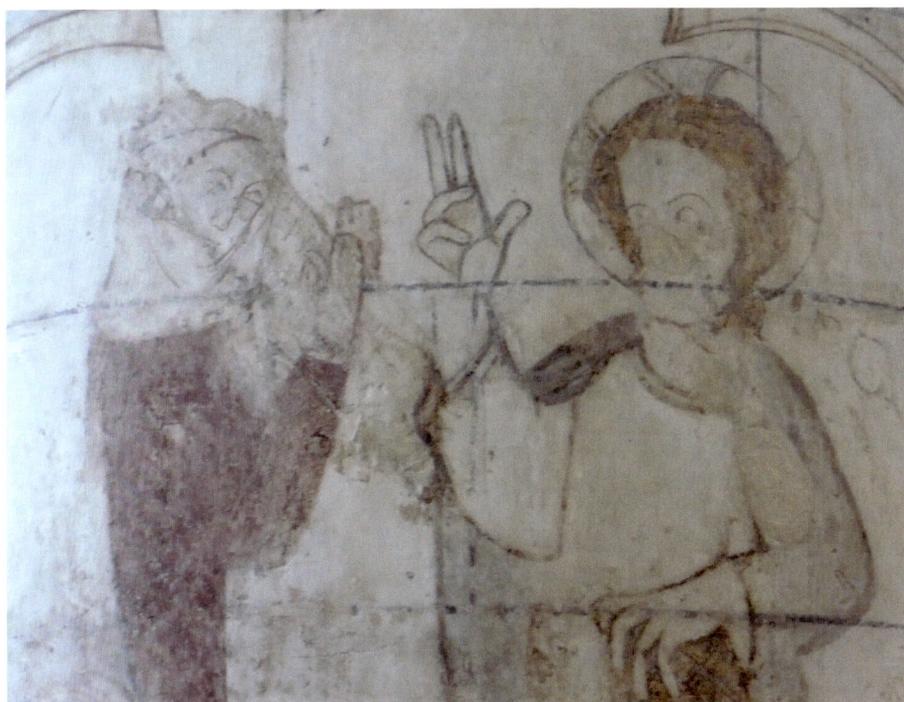

style matching the thirteenth-century arcades to the west but badly jarring with the original work opposite, a perhaps uniquely asymmetric arrangement. The abbey was dissolved in 1539, its church sold to the town in 1553 for £400 (about £196,000 today), and finally elevated to cathedral status in 1877.

I don't have room to do more than list a few of my favourite features. There are more medieval murals than in any other English cathedral, though sadly they're nearly all faded and fragmentary. In the nave, for example, are several powerful Crucifixions, and an early fourteenth-century Coronation of the Virgin, which gives particular prominence to Christ's hands. A mid-fourteenth-century oak room, like an elaborate garden shed, in the Saint's Chapel, from which an official would keep an eye on the pilgrims visiting the shrine of St Alban to see they behaved themselves. (It is the only undisputed watching chamber in the country; Christ Church Cathedral, Oxford, has what is sometimes claimed to be one, but which could be a chantry chapel.) On the north side the bressummer has a series of appealing little vignette carvings of everyday life: a sow suckling her four piglets, a shepherd serenading his flock with his double pipe, an acrobat, a milkmaid milking a cow, a cow suckling its calf; large mid-fifteenth-century doors, almost too elaborately traceried, now displayed in the south transept; a peacock in engraved glass (1988) by Sally Scott over the west door; and, perhaps best of all, the early fourteenth-century Lady Chapel. It's easy to see here why Thomas Rickman coined the label 'Decorated' in 1817 for this period of architecture.

Visitors will have their own opinion on the 'restorations' (which often amounted to complete rebuildings) of the cathedral by Edmund Beckett, Baron Grimthorpe. In his favour he allegedly spent £130,000 (something like £14 million today) of his own money on the works. And in the north transept he destroyed a large Perpendicular window – no great loss, in my view – and replaced it with a rose window, now filled with excellent abstract-geometric stained glass by Alan Younger (1988).

The cathedral must be one of the friendliest. On my most recent visit, groups of schoolchildren were scattered everywhere, all happily engaged, and a sense of the whole local community being welcomed – just as it should be.

31. St Albans, St Michael

St Michael is one of the few churches in the country that has specimens of all five of the main periods of English medieval architecture: Saxon, Norman (or Romanesque), Early English, Decorated and Perpendicular. The walls of the original Saxon nave, dating from *c.* 1000, largely survive, and now form the north and south arcades. The best details are the vestigial remains of windows above the arcades, their jambs and arches made from Roman bricks salvaged from the ruins of the Roman town. The Norman contribution was to add aisles in the early twelfth century by simply cutting plain semicircular arches through the Saxon walls. Curiously, no attempt was made to make the two arcades align with each other; the piers and arches on the north don't correspond to those on the south, so there's a disorientating sense of things being out of kilter.

Early in the thirteenth century the nave was heightened and clerestory lancet windows in the latest Early English style added, using Gothic pointed arches for

the first time. Probably just a few years later the south chapel was added. The east wall has a triplet of windows, the central one a roundel, framed internally by stylish shafts. Oddly, although the canopies of the outer windows are pointed, the windows themselves are round-headed. The Decorated style of the first half of the fourteenth century, which introduced the use of S-shaped ogee curves, is seen in a window in the north aisle; the stonework looks new but probably reproduces the original of about 1340. It's graceful though essentially composed of the simplest elements, merely four ogees, two smaller (springing from the central mullion) and two larger (springing from the jambs). The other windows in the aisle are Perpendicular, with mullions which rise right to the top.

The Victorians left their mark on the church too. Lord Grimthorpe demolished the west front and rebuilt it in his own clumsy style in 1898, resulting in an awkward assemblage of mostly Early English-inspired motifs. The most cack-handed feature is the buttress between nave and tower, which ruins whatever harmony the composition might have had, and notice the way the buttress's three unequal stages don't correspond with the tower's stages.

It was common for medieval churches to have a Doom painting prominently displayed over the chancel arch to remind the congregation of their fate. Only a few remain; what survives in St Michael's is the fifteenth-century painted wooden tympanum, which was originally an extension of the original mural. Six figures arise from their coffins (it's evident that the artist knew nothing of perspective), a pope, a king, a queen, and three citizens, all mostly naked except for their headgear. Most

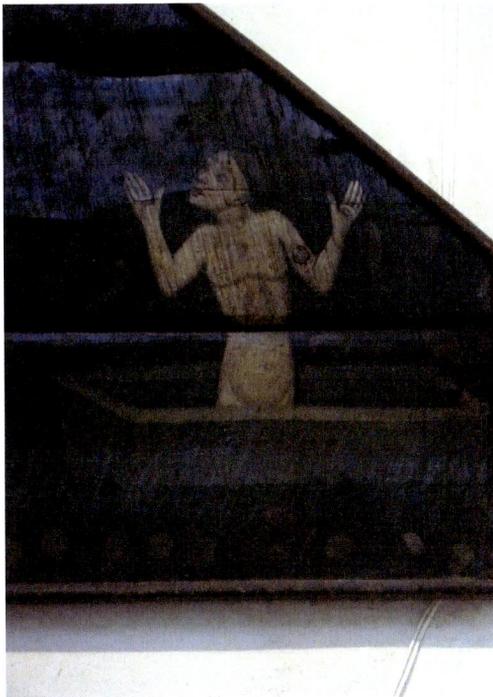

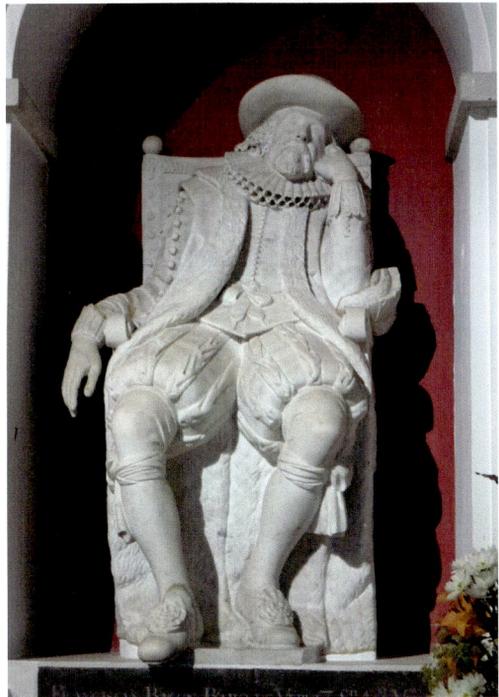

Above left and above right: St Albans, St Michael.

of them gesture in wonder and joy; the most tenderly human is the chap on the right, who looks surprised, even shocked, arms spread wide and mouth agape, to be witnessing the Last Things and to find himself on his way to Heaven.

Francis Bacon famously died (at least according to the gossipy John Aubrey) in 1626 of pneumonia, caught by stuffing a chicken with snow in order to study the effects of freezing on meat. His life-size monument shows him seated, an unusual posture for figures in monuments, and, even more unusually, and delightfully, he's having forty winks. This is very endearing, as if he were sitting for a portrait and just couldn't keep his eyes open. He's dressed in his best, including those absurd tied-up-above-the-knee breeches that look as if they've been inflated, and, below the knee, extravagant bows. A perky wide-brimmed hat tops off the sartorial composition.

32. St Paul's Walden, All Saints

There are traces of a Norman church if you look hard enough, but the core is fourteenth century, with later medieval additions. In one of the south aisle windows is a tender early fourteenth-century depiction of the Virgin and Child. Their faces are very worn, but enough survives to give the impression that they're looking at each other fondly, and the colours of their robes – hers, deep brown and olive-green, his, a rich red – still glow. Mary is crowned as the Queen of Heaven

Left and opposite: St Paul's Walden.

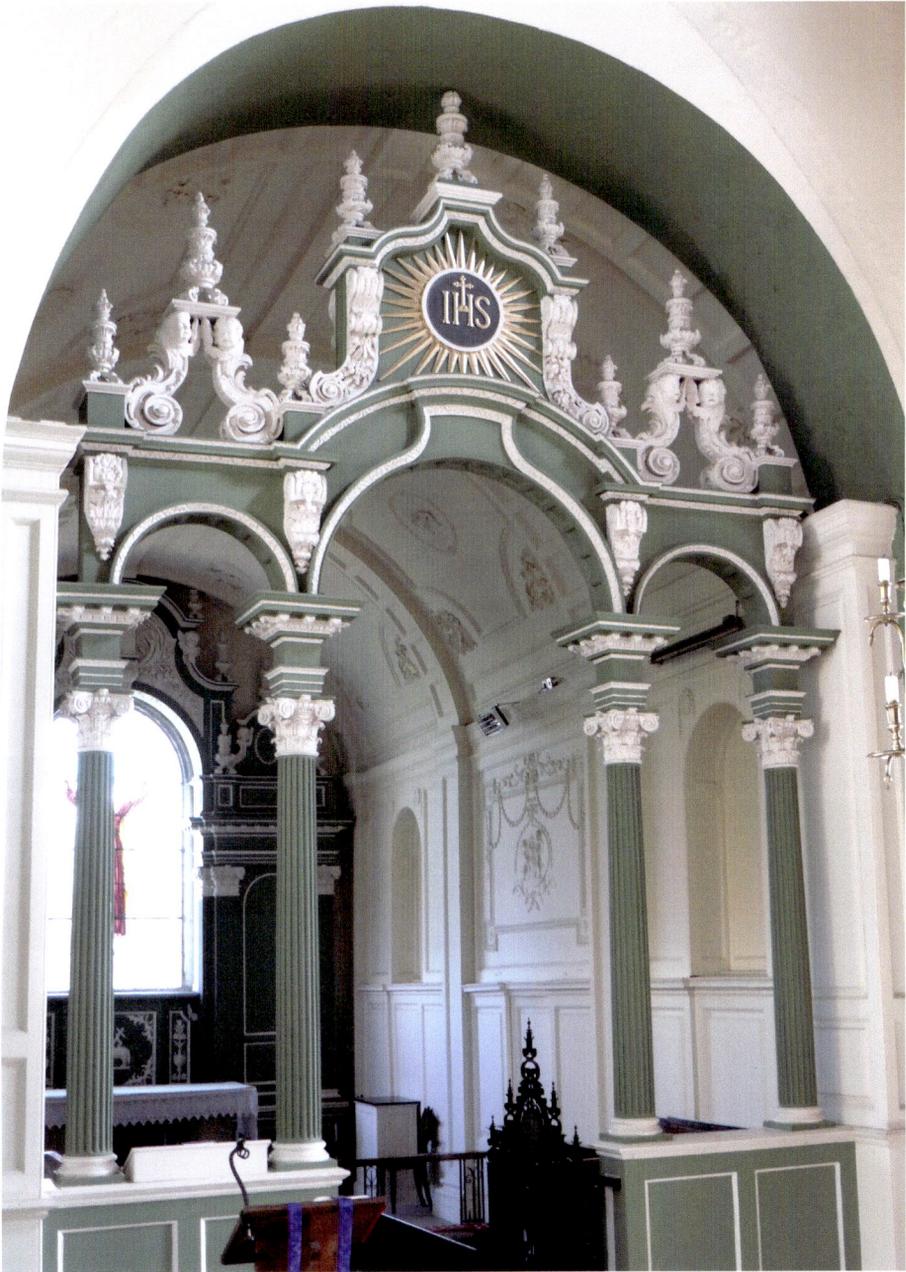

and holds an olive branch in her right hand. A bird perches on her left arm; this is probably intended to represent a goldfinch, which according to legend pecked a thorn from Christ's brow on the road to Calvary and was splashed with a drop of his blood; they often feature in such pictures as a means of reminding the viewer of Jesus's eventual fate. To modern eyes, however, it's simply a touching detail.

In most churches this would be the highlight, but here it's outshone by the chancel, refitted as a memorial to Edward Gilbert, who lived in the nearby Bury, after his death in 1762; the designer was very likely James Paine. There's nothing solemn or pious about the decoration; on the contrary, it's exuberant (arguably too much so for its relatively small size). The chancel screen has four fluted slim Corinthian columns, each with its own diminutive entablature; above them scrolls morph into pairs of putti, which support elaborate urns. These features are flanked by pairs of slightly smaller urns. The central, wider arch is topped with ogee curves and three more urns. Everything is garnished with fancy finials. It's as if Paine couldn't resist trying to use every device and motif he knew. Even the wrought iron gate is perfectly in keeping.

The reredos is similar, if marginally more sober. (What a pity about the regrettable 1946 Hugh Easton window, a vision of Christ as Superman, Hollywood-handsome, ready to zoom up into the sky with his cape billowing behind him.) The barrel vault is very prettily stuccoed; an unobtrusive inscription on an urn reads 'EG ob. 1762'. Two putti frolic around it, not looking at all grief-stricken; the one on the right has traditional feathered wings, but those of the one on the left look like a butterflies. It all makes me grin with sheer glee.

33. SANDRIDGE, ST LEONARD

Sandridge is one of those churches that has an outstanding headline act, but which turns out to have a fine supporting cast too. The star turn is a stone medieval chancel screen. There are only maybe a couple of dozen examples in English parish churches, and Sandridge's is the only one in Hertfordshire. When the screen was built in the late fourteenth century the original chancel arch was retained. This is of Roman brick salvaged from nearby Verulamium (Roman St Albans), and probably dates from *c*. 1100. Whether its preservation was a result of reverence for an earlier structure or a purely practical matter we don't know. Unusually, the screen is embellished with fleurons in the jambs on the east side, but is plain on the side visible to the congregation. When the church was restored in 1886–87 all the masonry forming the east wall of the nave was replaced with an openwork timber screen, in order to reduce the weight the stone screen was supporting. One captivating and individual detail of the screen is that on the east there are low buttress-like projections on either side of the door, with small reclining figures on them. The one on the south is bearded, while the figure on the north seems to be a woman as she has a wimple. He is certainly looking across at her, while it's unclear if she's looking at him or not. They relax there as if eternally listening to the services and each other.

The three-bay nave is late twelfth century, with square scalloped capitals on octagonal piers. Some of the capitals have odd volutes at the corners, like monstrous faces. There's an Enid Blytonesque charm to the three children presenting daisies to Christ in the St Christopher window, an early work by Christopher Webb (1916). John Hayward's 1957 window depicting St Michael slaying Satan in the form of a dragon is highly dramatic. The dragon is fearsome, but St Michael, with his flamboyant wings which almost cage it, is up to the task and stabs him with his spear-staff despite being encumbered with the scales with which he weighs souls.

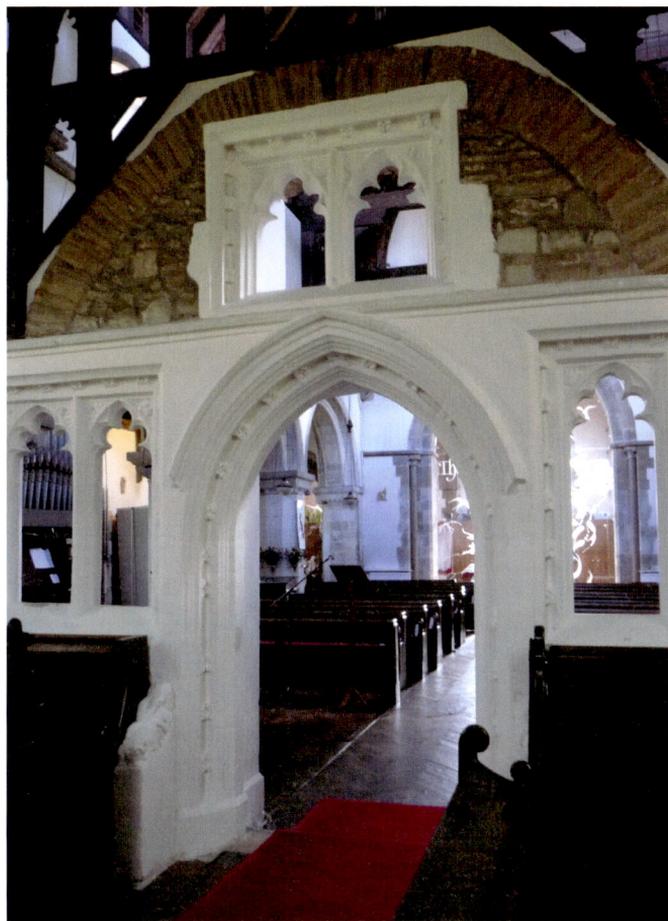

Sandridge.

34. SAWBRIDGEWORTH, GREAT ST MARY

At first sight ubiquitous Perp'n'flint, on closer inspection the church proves to have thirteenth-century origins and to be at heart a Decorated earlier fourteenth-century structure; see the quatrefoil piers and the north aisle windows. The spike on top of the tower is larger than usual and very attractively latticed.

However, it's not really the architecture we're here for; it's the monuments. What follows just scrapes the surface. I'd like to begin with the life-size brasses to John (d. 1435) and Katherine (d. 1437) Leventhorpe, but I've never seen them as they're covered under carpets, a clutter of tables and even a temporary altar. There are other, slightly later, Leventhorpe brasses on the wall under the tower; as was fairly common at the time they are depicted in his 'n' hers burial shrouds, hers secured at the head in a top-knot. Both hold their hearts, which once had prayers on them, since angrily defaced by an anti-popery iconoclast.

An anonymous canopied tomb chest in the chancel, dating from *c.* 1520, is typical of its period, being basically Gothic but with some transitional variations.

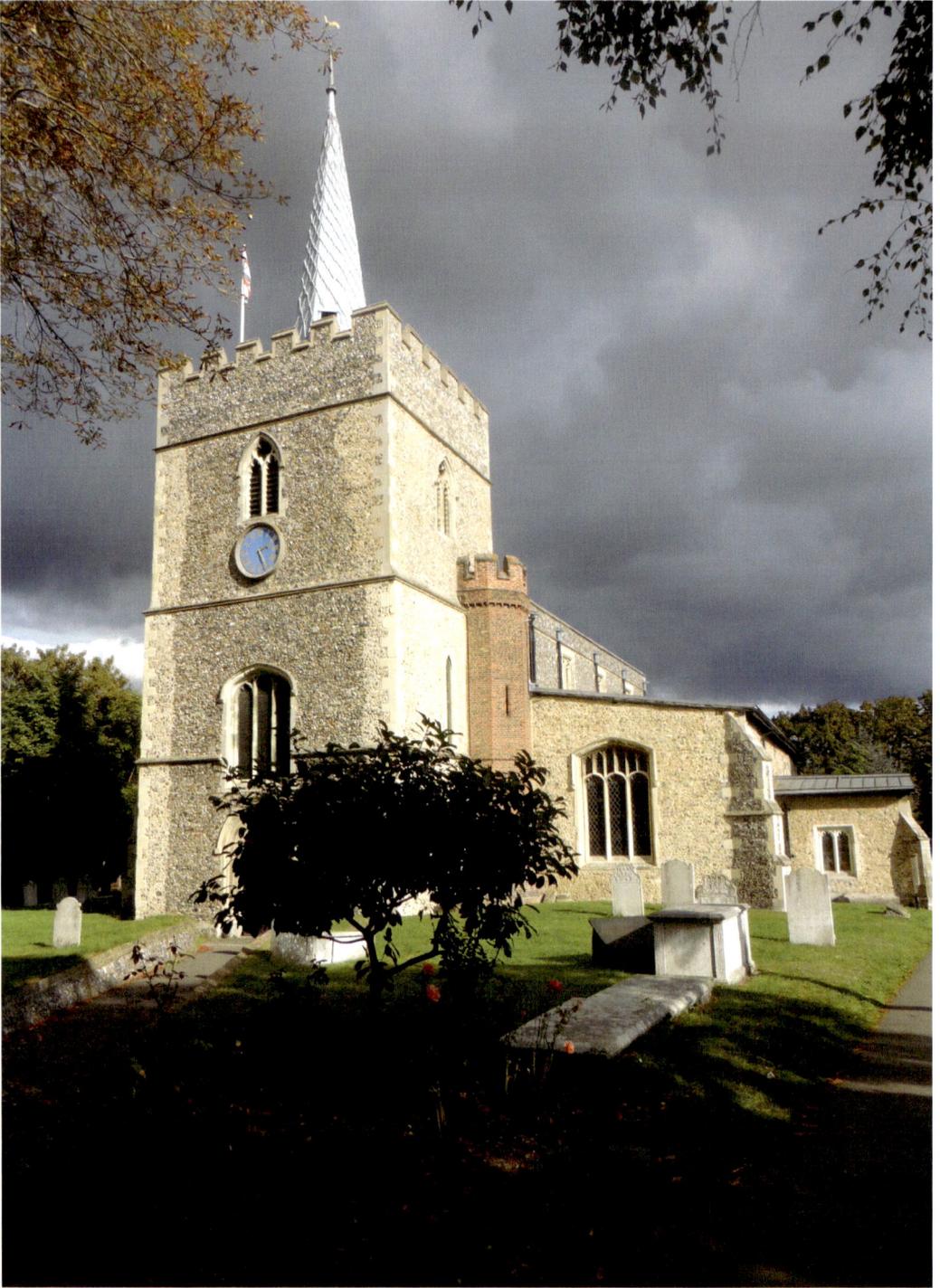

Above and opposite: Sawbridgeworth.

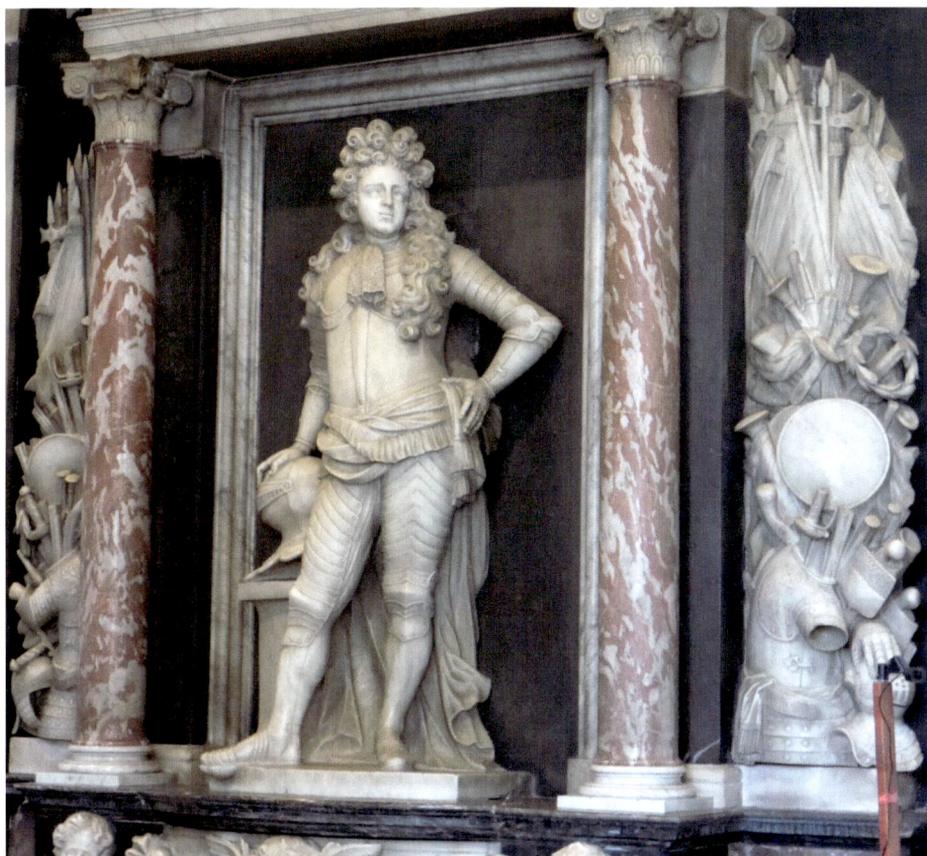

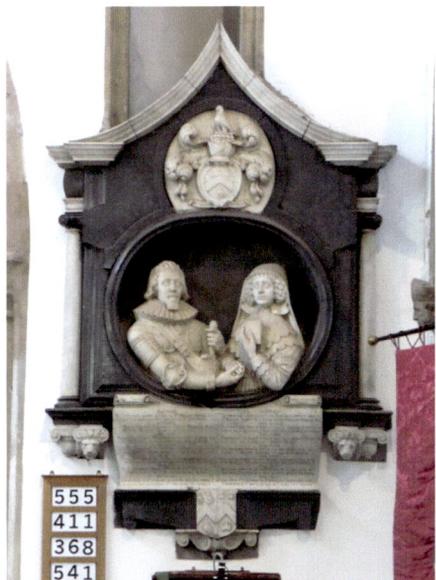

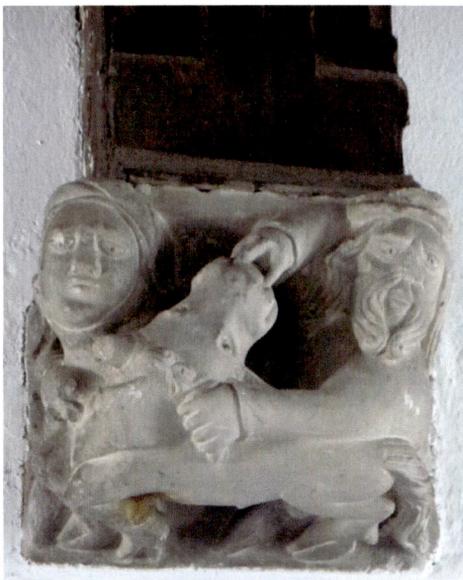

The vault has pendants which have traceried daggers, but these are uncusped and arranged at angles as if they are rotating clockwise, and the 'roof' has curved starfish-like quatrefoils. The engaged columns at either end are cross-gartered like Malvolio's legs. These details hint at the oncoming Renaissance (which of course was already in full swing elsewhere in Europe).

My favourite monument commemorates William Hewet (d. 1637) and his wife Elizabeth (d. 1646). He was a highly successful and wealthy merchant, but was briefly imprisoned in the Marshalsea in February 1617 for 'his contempt in not appearing before the lords when sent for'. Unfortunately the story behind this appears to have been lost. Perhaps the shock of this event was behind him leaving £200 (about £34,000 today) in his will for the release of prisoners with 'small debts'. He wears armour (though he wasn't a soldier), and they both stare out sightlessly (even the greatest sculptors struggle to make marble eyes lifelike). He and Elizabeth clasp right hands tenderly while he reaches awkwardly for his sword with his left. Their monumental marital fidelity has lasted four centuries so far, and won't be ending any time soon. The concave pediment is most unusual for its date.

Their grandson, George Hewyt (as his surname is spelt here) (1652–89), is swaggeringly commemorated in the chancel. He was created a viscount in April 1689, but enjoyed his title for less than eight months as he died later that same year. The Latin inscription says that he had 'scarce put aside his rattle when he donned a helmet as Captain-Lieutenant of the Queen's Guards for the remaining years of the reign of Charles II', so unlike his grandfather the armour he wears isn't fancy dress (but he almost certainly never saw action). He is supremely casual, yet projects confidence and power. His head is angled to the viewer's right, his torso to the left, and his legs to the right, creating a dynamic zigzag. The opulent curls of his long wig spill down over his shoulders, and at his neck a dandyish and unmartial lace cravat seems at odds with his armour. He is flanked by impressive/horrifying (delete according to taste) displays of military hardware. The monument is possibly by William Stanton (see Ardeley and Flamstead).

Much less sophisticated, but in their own way just as engaging, carvings are to be found in the corbels. For example, there's a man with two piglets, a fox running off with a goose, and a couple trying to restrain or control a cow; he is grabbing it by a horn and has the fingers of his other hand in its nostrils.

35. SOUTH MIMMS, ST GILES

South Mimms is practically on the hard shoulder of not only the M25 but also the A1(M), but still has the feel of a village. The church is externally typical Herts Perp'n'flint, over-restored (by G. E. Street, in 1876–78), but, as so often, appearances deceive and there's much to savour.

There are seven substantial fragments of stained glass in the windows of the north aisle and brick north chapel (built *c.* 1526). They depict members of local families at prayer, kneeling before lecterns on which open books are displayed. They are donor figures; when individuals or families paid for windows (or paintings) like these they wanted to advertise their piety, wealth and taste by having themselves included in the finished artworks. Originally the figures (dated 1526) would have been seen to be praying to Christ and the saints depicted in the

larger parts of the windows, but one day, probably just a couple of decades later in the mid-sixteenth century (under Edward VI), or possibly in the mid-seventeenth century (under Cromwell), iconoclasts turned up at the church to piously smash all images then seen as idolatrous. The kneeling citizens weren't being worshipped so they were permitted to remain, so at least there's now something left for us to admire, though these fragments are a pathetic reminder of how much more has been lost. The painted details have faded badly, but the colours are still bright, especially the blues and deep purples of the figures' robes.

Also in the north chapel is the canopied tomb of Thomas Frowyk (d. 1523), a standard though well done late Gothic Perpendicular affair with an almost flat four-centred arch and quatrefoils. Henry's effigy rests his head on a very elaborate helm, and one of his gauntlets is on the 'ground' by his knees; it looks disconcertingly like the star of the old horror film *The Beast with Five Fingers*. (Incidentally, the author of the original story, W. F. Harvey, is buried in the churchyard of St Mary, Letchworth, Hertfordshire.)

It's fascinating to compare this tomb to that of his father, Henry (d. 1527), in the chancel. (At least it's probably a tomb, but it has been suggested that in fact it's an Easter sepulchre.) This can't be more than a dozen or so years later than the earlier monument, yet the style, while retaining Gothic features (quatrefoils and four-centred arches, for example), is very different. The basic layout is the

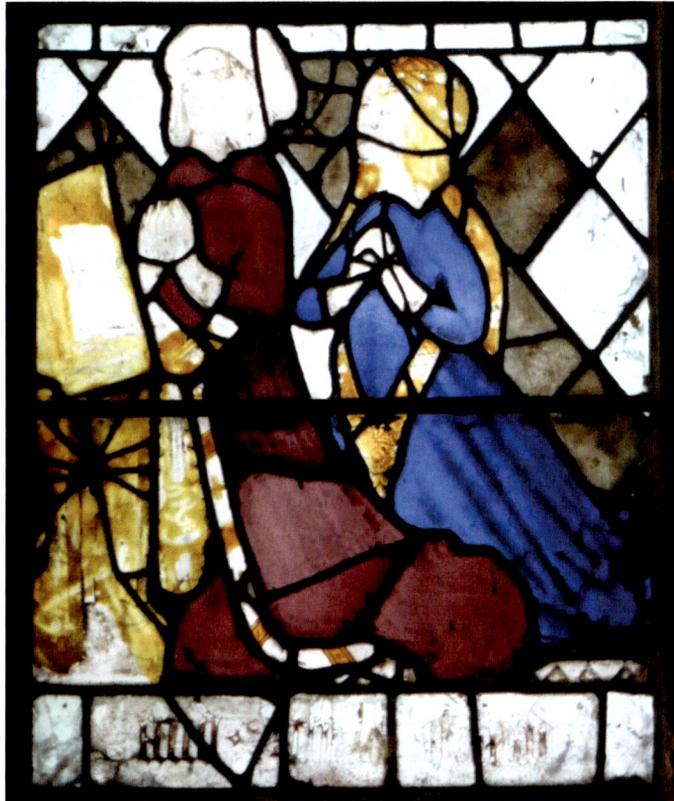

South Mimms.

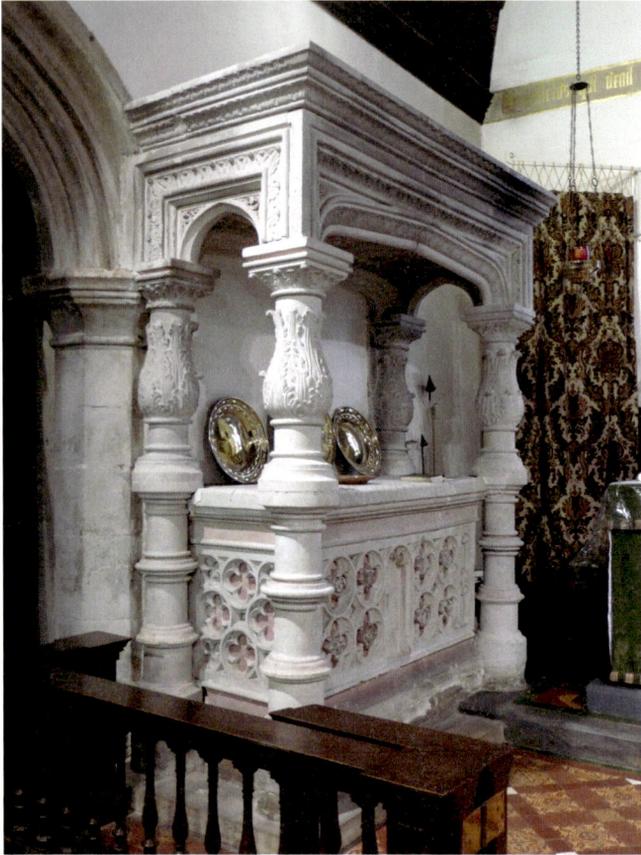

South Mimms.

same (minus the effigy), but much of the detail is lavishly Renaissance. This is an important transitional piece, showing how swiftly, and presumably willingly, the new style was adopted, but also, paradoxically, the innate conservatism of the masons who evidently still felt at home with a style (Perpendicular) that was almost 200 years old.

36. STANDON, ST MARY

The architectural highlight of Standon church, which stands on a steep slope, is the chancel arch. It's marvellously extravagant and full of swagger, with its dogtooth ornament and stiff-leaf capitals, and made all the more imposing by being approached up eight steps. It dates from the early thirteenth century; however, the detached pink Devonshire marble columns are replacements dating from the 1864 restoration.

Apart from the chancel most of the church is earlier fourteenth-century Decorated; the tracery in the west windows is some of the best in the county. The proud angular nave arcades, however, look later.

In the north aisle is a tomb-chest with one of the county's biggest and best brasses, originally inlaid with colour, depicting John Feld (or Field) (d. 1474) and

his son, also John (d. 1477). They both stand on flowery hillocks, a rebus (visual pun) for 'field'. John Sr (on the left) has an unfortunate haircut but is sumptuously dressed in his aldermanic robes, with the train of his cloak flung casually yet artfully over his left shoulder. He started his business life as a stock fishmonger (a dealer in dried, unsalted fish) in the Staple of Calais (an English possession from 1347 to 1558), and evidently made a great success of it. In 1453 he loaned £2,000 to King Henry VI for the defence of the town, the equivalent of about £1.25 million today. He must have sold an awful lot of cod. His wealth is signified by his purse hanging from his belt.

His son may well have fought for the Yorkist cause in the Wars of the Roses, a possibility somewhat belied by his foppish long wavy hair, which would certainly be regarded as unsoldierly in more modern times.

Another father and son are commemorated in the chancel. On the south is the dignified monument to Sir Ralph Sadleir (1507–87). He had an unusually eventful career, starting out with the advantage of joining Thomas Cromwell's household

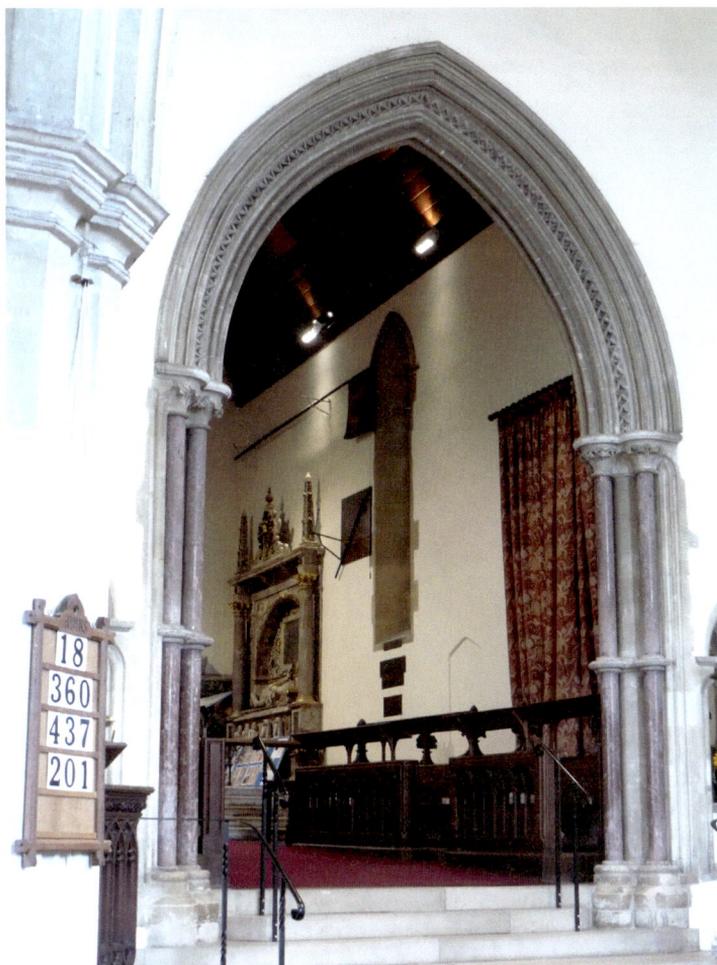

Standon.

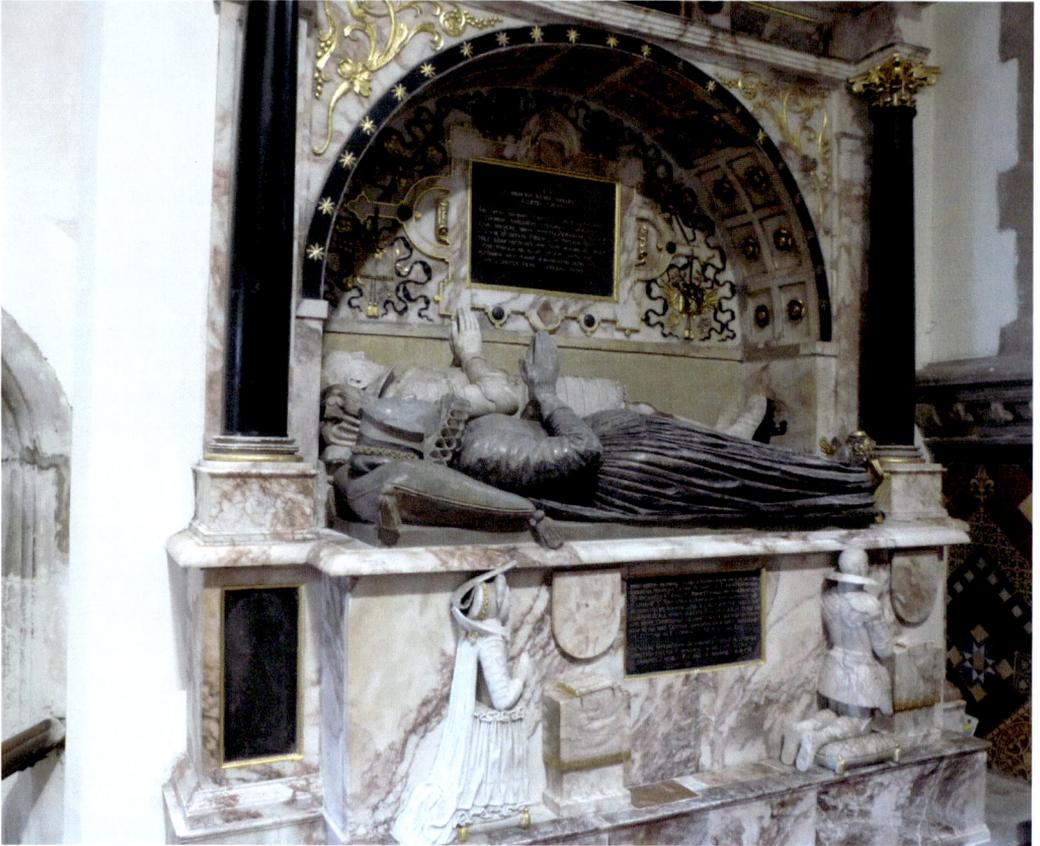

Standon.

at the age of about seven and rising to be his secretary. This became a distinct disadvantage with Cromwell's fall from royal favour in 1540; Sadleir was arrested and sent to the Tower, but he cleared his name and was soon back at work. He became allegedly the wealthiest commoner in England.

His life, however, was touched by scandal. In 1535 he married a widow, Ellen (or Helen). Her first husband was presumed dead. However, in 1545 he reappeared, and Ralph and Ellen's seven children became illegitimate overnight. It took an Act of Parliament to sort out the mess. Their children appear on the tomb, but there's no sign of Ellen; no one knows why.

Ralph and Ellen's son Sir Thomas (1534–1606), whose monument (recently conserved, like that of his father) is on the north of the chancel, on the other hand is shown with his wife. Below are the kneeling figures of a woman and a man; the former wears the most extraordinary headgear, presumably of stiffened cloth. It begins as a pillbox hat on the back of her head to the top of which is attached a kind of vane, which starts by heading downwards, then curves up and finally sticks out over the top of her head. It's as if it's designed so someone behind her can rest their book on it, like a perambulatory lectern.

37. STANSTEAD ABBOTTS, ST JAMES (CHURCHES CONSERVATION TRUST)

Stanstead Abbots, although mostly built in the thirteenth and fifteenth centuries, is the best place in the county to imagine what attending church was like from the later sixteenth century right through to the earlier nineteenth. After the Protestant Reformation sermons were preached more often, lasted longer and became the central focus of services. Box pews evolved to accommodate this development. They enclose a seat or seats in a 'box' of four wooden walls with a door; their purpose is to provide some comfort for the congregation so they can concentrate more effectively. The walls keep out the draughts (most important before heating was introduced in the nineteenth century), but also provide privacy for the occupants. Stanstead Abbotts' box pews are clustered around the pulpit, which is positioned on the south wall of the nave. They're plainly panelled and roughly chest high, or a little taller. They're thought to date from *c*. 1700. (Some of those in the north chapel have little peepholes cut in them, the exact purpose of which is unknown; maybe they were intended to encourage servants to behave by making them feel watched.)

It's worth sitting in one of the pews with the door shut behind you to begin to conjure up some sense of what services were like during the age of worldly, plump Parson Woodfordes droning their sermons while somnolent Squire Allworthys snoozed. The chunky, probably late sixteenth-century pulpit is a three-decker – that is, it has three seats at different levels. At the bottom is a seat for the clerk,

Stanstead Abbotts.

who would have led the congregation's responses. Above this is one for the presiding priest, and at the top is the pulpit itself, to which the priest would ascend to preach. Originally there was a tester, a sounding board to help project his voice to the listeners, but somewhat bizarrely this has been removed and incorporated into the west door.

Together with the pews and pulpit, the seventeenth-century altar rails, altar table with curly legs, faded mural texts, heraldic glass (dated 1573), commandment boards and royal coat of arms (dated 1694) over the altar comprise a fortuitously preserved and eloquent ensemble.

The north chapel was added in 1577, as a datestone over the east window attests. Not much church building was done under Elizabeth, and this is an early example of the Gothic Survival; stylistically the chapel could easily have been built a century (or even two) earlier. The windows are Perpendicular, the four-bay arcade typical of the same period.

In the chapel is a 2013 window by Thomas Denny, one of the finest stained-glass artists currently working (there's another one by him in Wigginton, from 2019). The glass has been not only painted but also treated by acid etching and flashing (sandwiching two layers of differently coloured glass, and exposing parts of one of them through the other). The result is that his windows have texture, as well as colour and shape, which is one reason why they're so richly appealing. There are two lights, which share the motif of a couple (on the left) and a man (right)

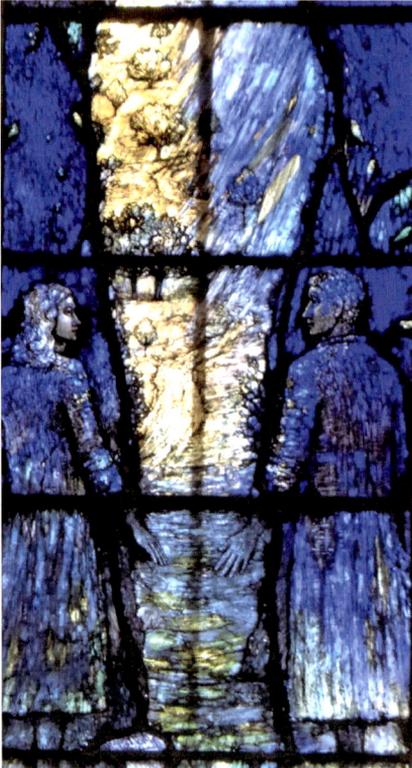

Stanstead Abbotts window by Denny, 2013.

looking through a tall narrow gap to a distant landscape, and the use of much blue (with hints of purple). The couple are about to join hands and walk into the golden arboreal countryside, while the man is in a library where the curtains blow aside to reveal mountains on the horizon. The window evokes a marvellous sense of a numinous Beyond.

38. THROCKING, HOLY TRINITY

The most eye-catching feature of the exterior of this mostly Perp'n'flint church is the upper stage of the tower, built in rich red brick and dated 1660 in an ornate panel with cute little comma-like volutes on each side. The stair turret on the south-west corner and the prominent elaborate moulded string courses have the effect of

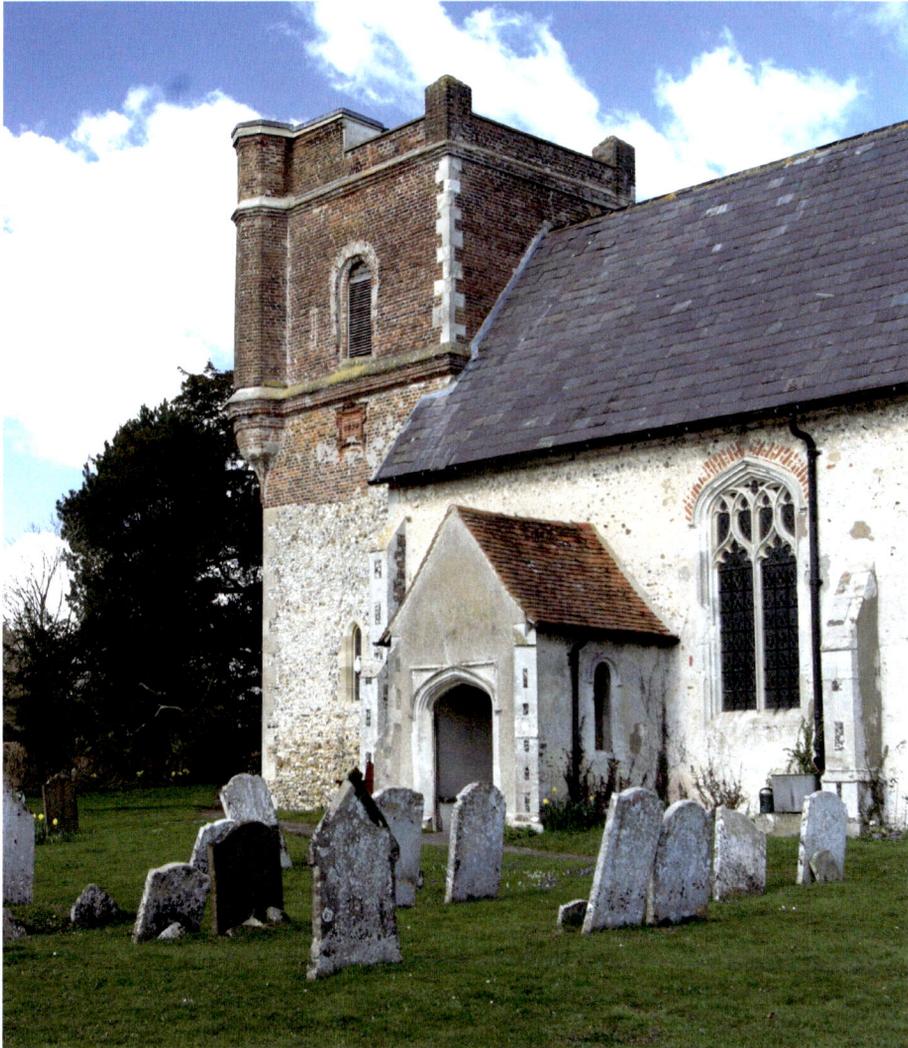

Throcking.

making the whole thing seem quirkily top heavy, as if the builders couldn't quite contain their exuberance. (There were originally pinnacles too.) The work on the tower was paid for by Sir Thomas Soame, whose memorial is within the church. He was a Royalist politician and an MP from 1640 to 1648; he was once briefly imprisoned in the Tower of London for refusing to divulge the names and financial affairs of some of his fellow aldermen of London. He lived in Throcking, probably as quietly as possible during the Commonwealth to avoid the attention of the Parliamentarians, and financed the rebuilding of the tower presumably as a means of celebrating the return of the monarchy – a restoration to celebrate the Restoration.

The fifteenth-century font has eight different designs, either of tracery or flowers within quatrefoils, on each side. One flower has a face with a gaping mouth and, apparently, a protruding tongue, like a louche ancestor of Little Weed from *The Flowerpot Men*. In the chancel are two modern benches but with older poppyheads. Easily missed is one depicting three acrobats. Mysteriously, on the right a large bird (a goose?) turns its head round to watch their antics. All is vigorously and spiritedly carved. It's hard to date; perhaps sixteenth or seventeenth century? Is all this just a whim of the carver, or does it mean something? The medieval church looked askance at acrobats (and other entertainers), and they were sometimes used as symbols of ungodly behaviour. Geese are occasionally associated with the Holy Spirit (a sort of tougher version of the more usual dove), so maybe the message is 'God is watching when you sin'. But more likely it's just a light-hearted *jeu d'esprit*.

Throcking.

39. WALKERN, ST MARY

At first sight our impression is that Walkern church is mostly typical Herts fifteenth-century Perp'n'flint, which is true enough as far as it goes, but step through the door and we realise that its origins are nearly half a millennium earlier. We are faced with two very plain arches; they are late eleventh or early twelfth century, but they have been cut through an earlier wall. The evidence for this is that the wall is only 2-feet 3-inches (69-cm) thick, whereas Norman walls are generally much thicker, and that the imposts, one of which has four layers of cable moulding, look Saxon. They were probably once the imposts of the south door, because what we're looking at is the original south wall of the nave. The clincher is a figure of Christ from a Crucifixion, which was on the outside wall of the church (perhaps immediately over the door) but is now in the south aisle. It seems to date from the mid-eleventh century. The stylised, solemn head is in high relief; where the torso and outstretched arms once were have been cut away (perhaps to accommodate a beam). From the waist down is depicted by incised lines. He is wearing a tunic, whereas in later depictions of the Crucifixion Christ is almost always naked. The figure's primitive (I use the word non-pejoratively) power pervades the whole church.

The church's other outstanding feature is an early thirteenth-century monument to a knight, traditionally said to be William de Lanvellei, who died in 1217.

Above left and above right: Walkern.

William was the Lord of Walkern and the Governor of Colchester Castle during the troubled reign of King John (1199–1216). The Purbeck marble chain-mailed effigy certainly reflects the brutal, chaotic times. It's one of only three in the country to wear a helm that completely obscures the face: the effect is forbidding, alien. A medieval Cyberman. This is compounded by his hand grasping the hilt of his long sword (which extends down to his feet), apparently in the act of drawing it with hostile intent. It is the stuff of nightmares.

40. WATERFORD, ST MICHAEL AND ALL ANGELS

Fairly small, unassuming, Victorian and at first sight easy to pass by. But doing so would be a serious mistake. It's from 1871 to 1872, in the style of the early fourteenth century, and by Henry Woodyer, a wealthy eccentric who berthed his own steam yacht in the Mediterranean and carried his architectural plans rolled up in his umbrella. However, it's the church's contents that make it special and unmissable.

The chancel was lavishly decorated with mosaics and opus sectile from 1901 to 1912 (the work on the north side cost £300, about £28,000 today). Even though the light through the windows is dimmed by the stained glass, the walls glitter and glimmer and shimmer. It's like being inside a kaleidoscope. The background blue is the dominant colour, with several different greens also prominent, gold and red and white adding contrast. The tesserae have been laid not quite flat on the walls so that they catch the light at different angles in order to maximise the dazzle. The overall effect is quite exhilarating in its peacockery.

Waterford.

What's more, every window is filled with stained glass, much of it Pre-Raphaelite and gorgeous. In the east window the beautiful Nativity (1872) is by Burne-Jones; Mary seems to be nodding off – and who can blame her, as no doubt she's shouldered the main burden of getting Jesus down for his nap. Her husband has evidently been little help; he reads his book and is perhaps about to ask if his dinner is ready yet. The surrounding musician angels, Pre-Raphaelite stunners all, are by William Morris; they're static, but highly decorative. I especially like the backgrounds of trees against woven willow fences.

Justly the most famous window is Burne-Jones' depiction of Miriam (1872). She is shown clanging cymbals together as she leads the Israelites in a song of celebration after they've escaped captivity in Egypt. She is vigorous and spirited, her body twisting while she turns her handsome profile to her right, her hair flying, all set against luscious pomegranate trees.

There are other Burne-Jones (some of them much later in date and different in style) and Morris windows, one by Selwyn Image and two panels by Ford Madox

Waterford window by Burne-Jones & Morris, 1872.

Above left: Waterford window by Burne-Jones, 1872.

Above right: Waterford window by Parsons, 1929.

Brown. On the north are two from the twentieth century: a slightly disappointing one by Douglas Strachan (1928), and, most eye-catching of all, one by Karl Parsons (though based on a design by the great Irish Arts and Crafts stained-glass designer Harry Clarke) (1929). It's of St Cecilia, the patron saint of music, who, red-haired, looks up as if in a trance, her hands raised as if ready to catch something. An angel hovers over her, about to crown her with a floral tiara. Her golden halo seems to be made of flames (perhaps a visual representation of musical inspiration). Every square inch is crowded with etched, flashed or painted detail. Marvel at those clothes or flowers, for example. It's almost overwhelming, but marvellously so.

41. WESTON, HOLY TRINITY

Push open the south door and look 45 degrees to the right to discover a prospect through four Russian doll-like arches, space unfolding from space in a manner rarely found in smaller churches. The first and nearest is that of the Perpendicular

south aisle arcade, of the fifteenth century and with stubby octagonal columns, but through this is visible an austerely plain Norman chancel arch, and through this another Norman arch leading into the north transept, and through this in turn the outline of yet another Norman arch (once the entrance to a long-demolished apse) can be glimpsed.

We are looking at a complete twelfth-century Norman crossing. The eastern capitals have simple decoration; one has crescent shapes, mostly adjacent to each other but some of which overlap, as if the mason miscalculated or changed his mind halfway through.

The chancel is in complete contrast to the rest of the church. It's of 1840, brick (once stuccoed), and is by Thomas Smith. He built it in the Neo-Romanesque style to complement the crossing, and, although its air of sophistication doesn't have much in common with the original's primitive starkness, it's most enjoyable in its own right, especially the extravagantly unnecessary bravura hammerbeam roof with gilded pendants.

The nave and south aisle contain an excellent collection of corbels, twenty-nine in all, mostly fifteenth century but with some good Victorian ones among them. (It's not always easy to tell which is which as they are, of course, high up.) For example, there's a sinister figure pulling his hoody away from his face to shout insults

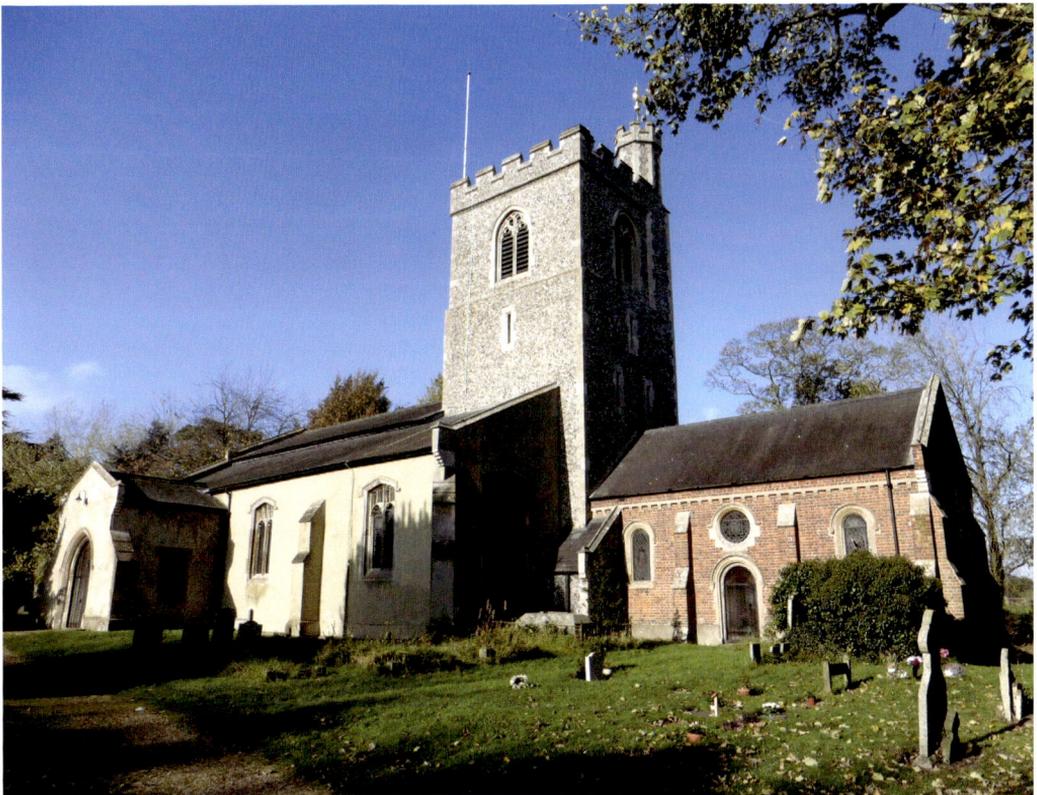

Weston.

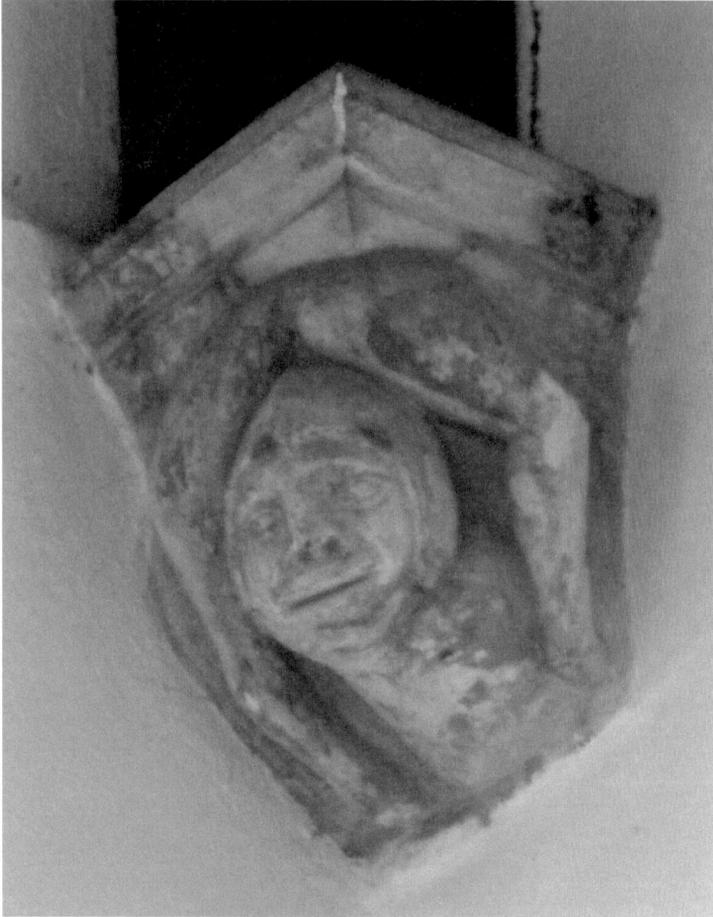

Weston.

across the nave, a grinning, gurning mouth-puller (a surprisingly common motif in churches), a startled bearded man, and a crowned figure sticking out their tongue.

Most interesting of all in the south-east corner of the aisle is an acrobatic anus shower* (apparently it's never been recognised as such before). The cheeky chap in question has his head between his legs and stares us out unashamedly and uncompromisingly while mooning us. Such exhibitionists aren't common in churches (and this is the only one in the county), but they're to be found more often than might be supposed. What do they mean? We'll never know for certain (though we can dismiss out of hand the claim that they're the mason's rude response to being unpaid), but the three most likely explanations are that they're apotropaic (that is, intended to ward off evil), that they're examples of medieval humour, and that they're warnings against the sin of lust. Of course, all three

* Thanks to the ambiguities of English, it's easy to initially read this not as a shower as in a showing, but as a shower as in a rain shower. But a shower (in the latter sense) of anuses does sound quite amusing in a surreal kind of way.

could be true at different times and in different places. For what it's worth, I think the last fits the evidence best in this instance.

I want to emphasise most strongly that it's a mere coincidence that I follow this gallery of grotesques with the roster of rectors. In most churches this is a dry list of names and dates, but here we have photos too, all the way back to the mid-nineteenth century. Some of the Victorian ones look pretty fearsome.

42. WHEATHAMPSTEAD, ST HELEN

The most striking external feature is the extraordinary spire, a steampunk rocket ready for blast off. In its present form it dates from only 1865–66, and replaced a similar structure of uncertain date (but I'd guess post-medieval). The chancel was originally apsidal, but was entirely reconstructed *c*. 1230 in the Early English style (exemplified by the lancet windows on the north, complete with dogtooth decoration).

About half a century later work started on the crossing and tower. I really like cruciform churches; it is a wonderful thing to stand under a central tower and be able to look in every direction and have changing, exciting vistas unfold. Wheathampstead's crossing arches are lofty and sturdy, though not elaborately decorated. They and the tower they support were partly paid for by people eager to escape some of the punishments due to them when they reached Purgatory. In 1290 the Bishop of Lincoln granted indulgences of twenty days to all who contributed money towards the project; in other words, he declared that they'd reach Heaven nearly three weeks early if they dipped into their pockets. I don't know if it worked for them, but the earthly result – the crossing – certainly works for me.

The transepts are even better. They're perhaps the county's best parish church examples of Decorated Gothic, from the first half of the fourteenth century. Many of the windows have graceful, variedly curvaceous tracery and some are embellished with carved ballflower and fleurons. For example, the east window of the north transept has them, externally, in the arch, on the jambs and even on the mullions, plus, internally, two bands in the arch. What's more, beneath the window is a reredos consisting of seven shallow niches, in which statues once stood, the crockets of which are almost obsessively richly carved. There can't have been any money worries during this phase of building.

The piscina has the most extravagant and tallest canopy I've come across, probably late fourteenth century, with nodding ogee arches at the top of the tall, skinny 'windows'. The underside has a miniature vault and there are even flying buttresses.

The grandest monument commemorates Sir John (d. 1637) and Elizabeth (d. 1632) Garrard. One unusual feature is that instead of both looking straight ahead, she twists around as if to catch a glimpse of her husband behind her to see if he is following her. I especially like the leopards (the crest of the Garrards) and in the right spandrel a skeletal, terrifying Time as Death, holding an hourglass and brandishing an arrow. The ribs must be carved from the same block of alabaster as the rest of the figure.

There's a window of 1908 by the Scottish Arts and Crafts artist Douglas Strachan (pronounced 'strawn'). It depicts the Annunciation; the flashes of strong colour –

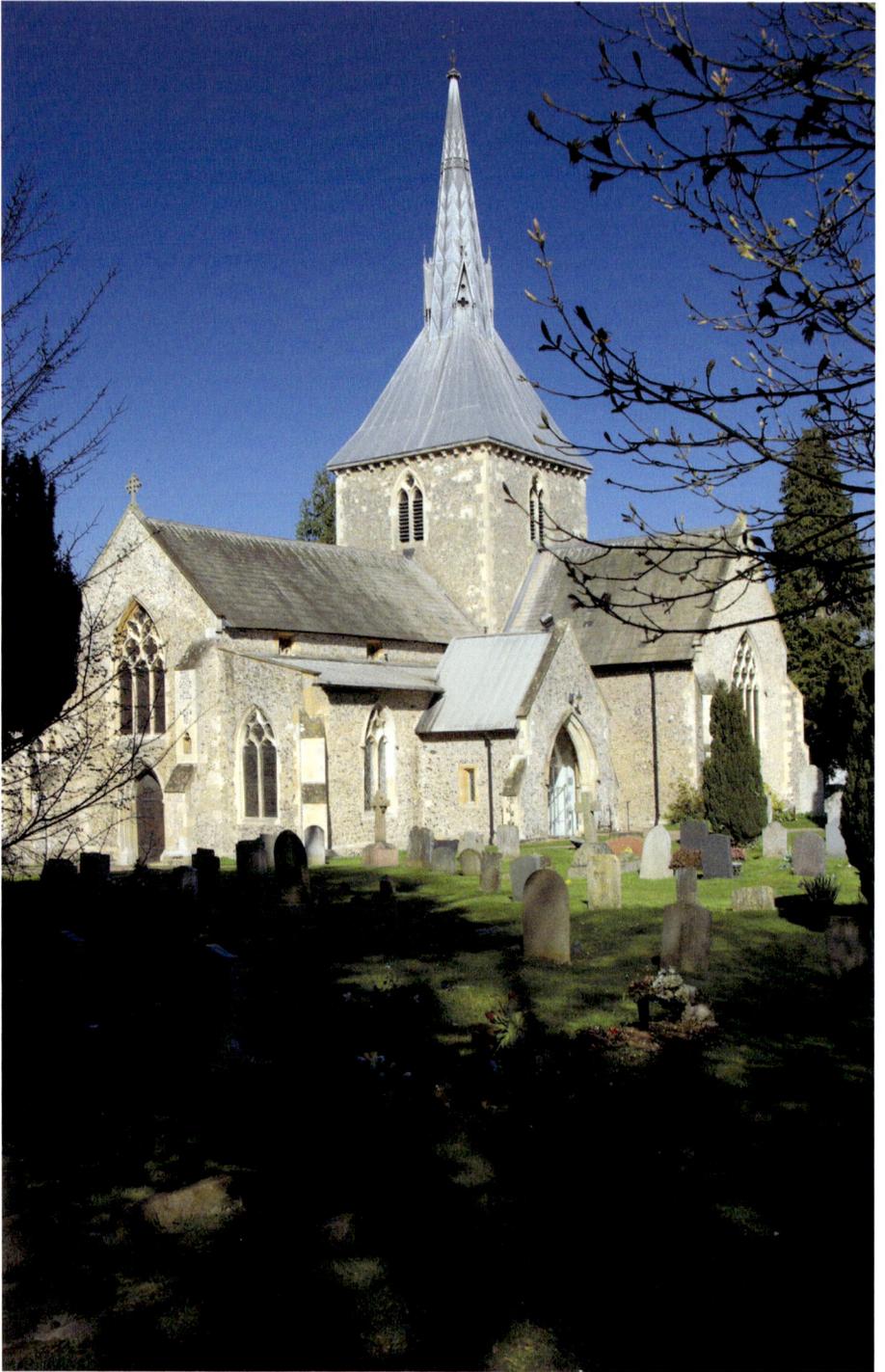

Wheathampstead.

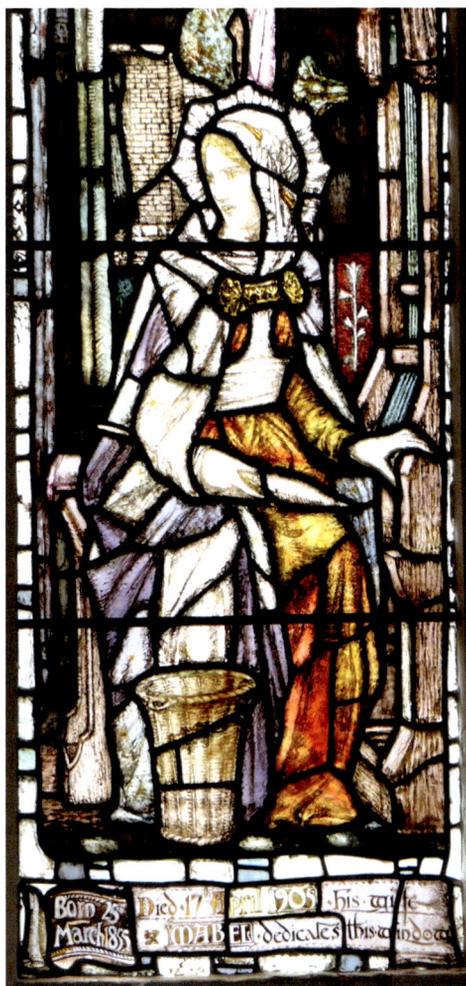

Wheathampstead window by
Strachan, 1908.

Gabriel's pale gold sandals, the red of the cloth hanging from the lectern on the
bottom left, Mary's yellow-gold skirt and pale purple cloak – are most striking.
Every pane of glass is beautifully textured and crammed with closely observed detail:
the little glimpse of the spires of a city just below the dove of the Holy Spirit; Mary's
basket and hanging lamp; the Gothic carving at the top of her loom; the garden with
daisies to the right of Gabriel; the glass shaped like a decanter at his feet.

43. WYDDIAL, ST GILES
All late medieval, most of the interest is concentrated in the brick north aisle, built
in 1532, just four years before the beginning of the Dissolution of the Monasteries
(which marked the end of the English Middle Ages). The windows are of three
lights, each almost rounded rather than pointed, under a segmental round arch, and
completely lacking in cusps, showing the beginnings of a classicising spirit. Compare
them to the entirely classical north door from a bit less than a century later.

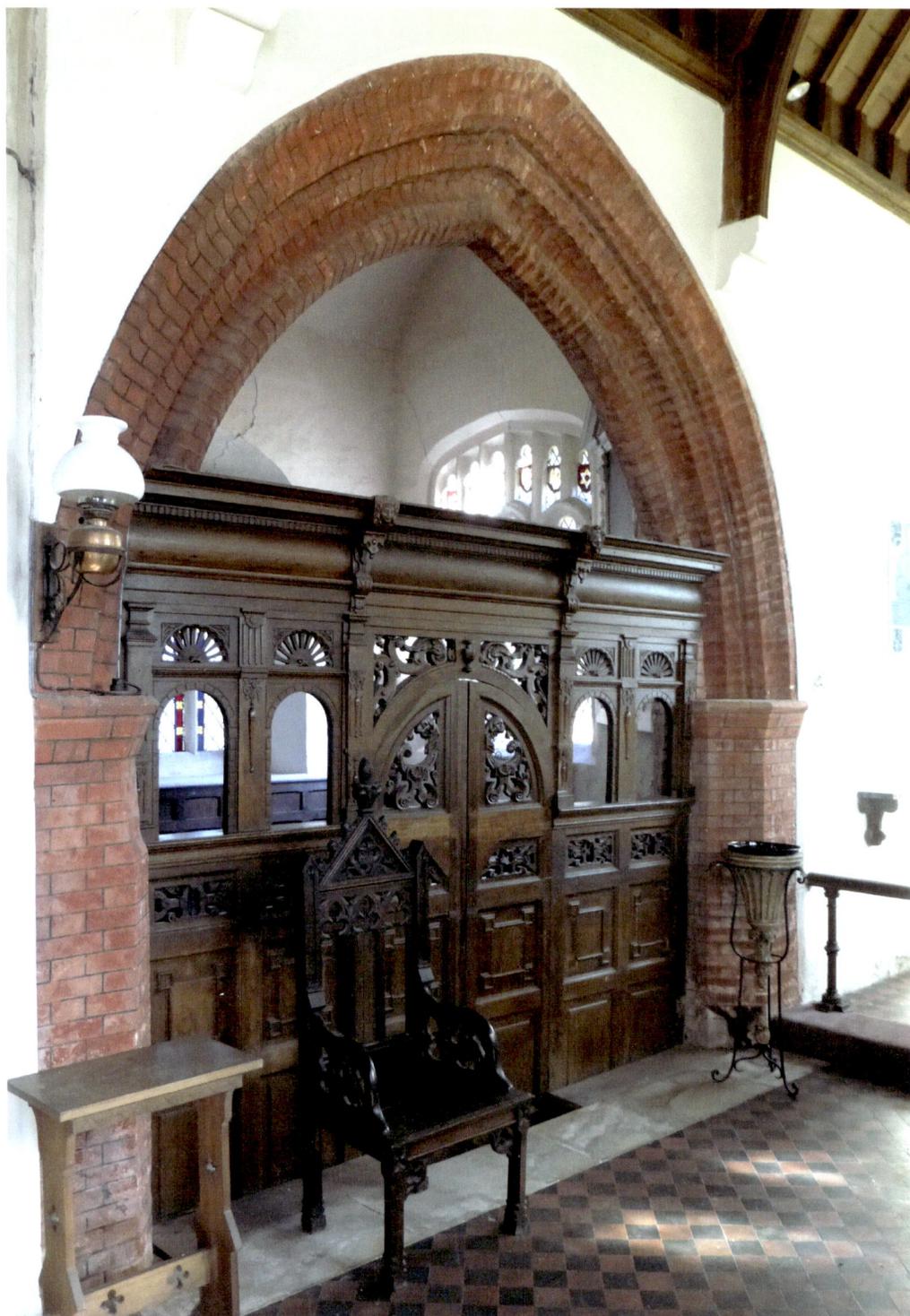

Opposite, right and below: Wyddial.

Inside there are some excellent Jacobean screens, full of fecund invention, and eight panels from a mid-sixteenth-century Flemish stained-glass Passion cycle. The sequence begins with the Kiss of Judas, whose face is tender despite his duplicitous smile. The artist has tried to make Jesus look holy but succeeds only in making him appear a bit dopey. On the left Peter, like an action hero with sword raised, is cutting off Malchus's ear, the latter's lantern and club spilled on the ground. In other panels we see Christ before the Sanhedrin, before Pilate (who washes his hands in a different scene), and before a villainous Herod, the Flagellation, and Christ carrying the Cross, all faded and worn but with much painterly Renaissance detail repaying close inspection.

The Goulstons moved to Wyddial in the early seventeenth century, and the north chapel contains several memorials to members of the family. The grandest is to Sir William (d. 1687), with a pair of putti at the top lolling languidly as if they're on sun loungers by the pool, two characterless busts, and, at the bottom, two armorial cartouches which morph into alarming grotesque faces. That to Richard (d. 1686) is a conventional stone mural monument but an attempt has been made to make it look more imposing on the cheap by painting fictive extensions on the surrounding wall. I like the cheek of these Goulestons (as the name is spelled here). He also has a brass, with a Latin poem, the key part of which translates as 'only the second syllable, stone, remains now', punning on Gouleston[e]'s name. Furthermore, the word 'lugeo' ('I mourn') features prominently, which is an anagram of the first syllable. It seems that the Goulestons (whose name isn't unlike my own), as well as being partial to cut-price grandeur, were pioneering crossworders, a trait I can sympathise with as I enjoy a bit of a skirmish with the *Guardian* and *Telegraph* setters myself.